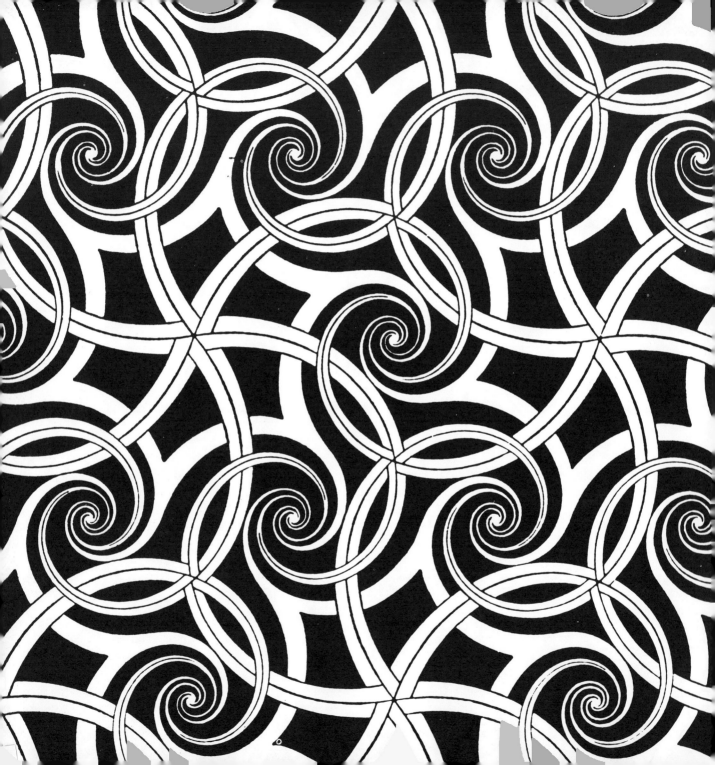

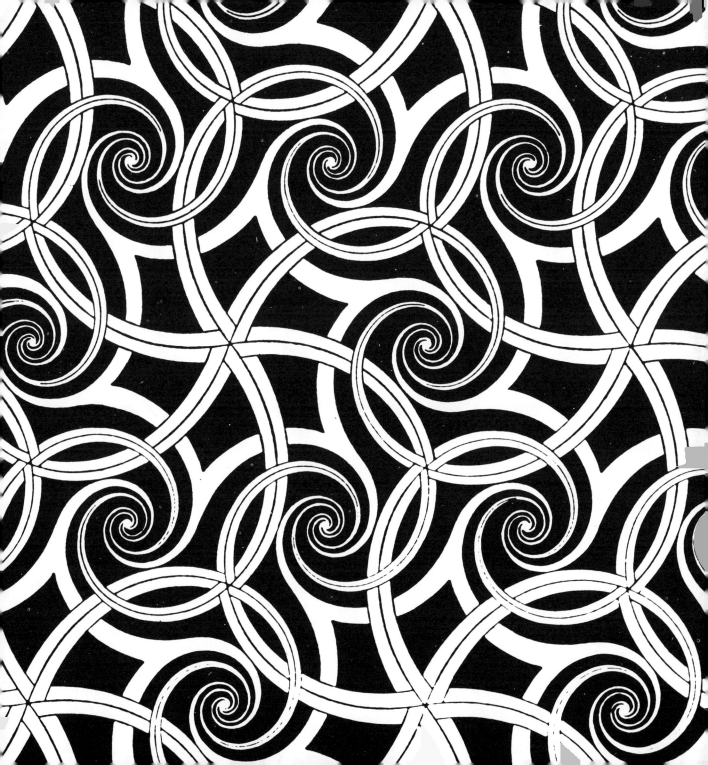

PRINCIPLES
OF
PATTERN
DESIGN

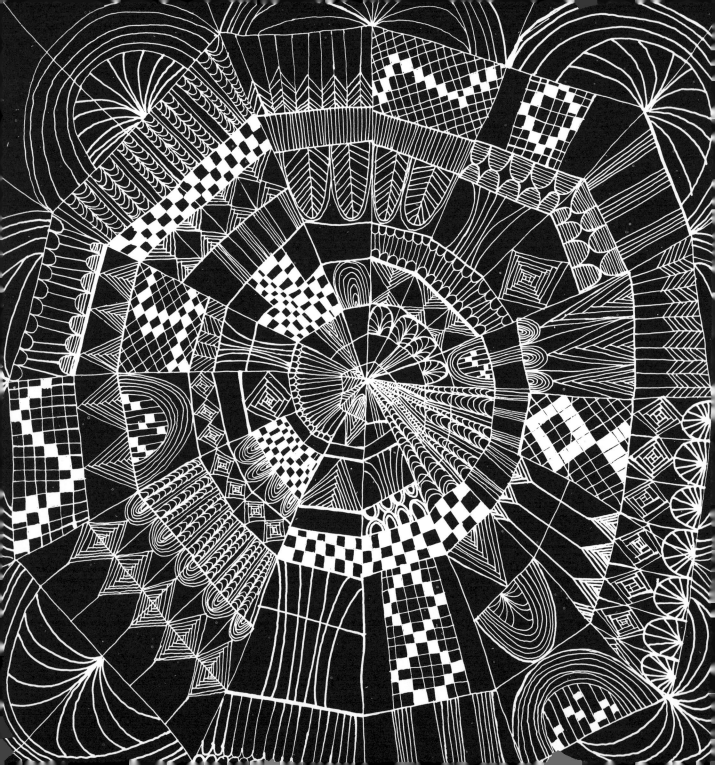

PRINCIPLES OF PATTERN DESIGN

BY

RICHARD M. PROCTOR

DOVER PUBLICATIONS, INC.
NEW YORK

This edition of *Principles of Pattern Design* is faithfully dedicated to my valiant friends living (and no longer living) with AIDS.

DESIGNED BY THE AUTHOR AND GEORGE H. BUEHLER

Copyright © 1969 by Litton Educational Publishing, Inc.
All rights reserved under Pan American and International Copyright Conventions.

Published in Canada by General Publishing Company, Ltd., 30 Lesmill Road, Don Mills, Toronto, Ontario.
Published in the United Kingdom by Constable and Company, Ltd.

This Dover edition, first published in 1990, is an unabridged, slightly corrected republication of the work originally published in 1970 by Van Nostrand Reinhold Company, New York, under the title *The Principles of Pattern: For Craftsmen and Designers*.

Manufactured in the United States of America
Dover Publications, Inc., 31 East 2nd Street, Mineola, N.Y. 11501

Library of Congress Cataloging-in-Publication Data

Proctor, Richard.
 Principles of pattern design / by Richard M. Proctor.
 p. cm.
 Reprint. Originally published: The principles of pattern for craftsmen and designers.
New York : Van Nostrand Reinhold. 1969.
 Includes bibliographical references.
 ISBN 0-486-26349-5 (pbk.)
 1. Repetitive patterns (Decorative arts) I. Title.
NK1505.P7 1990
745.4—dc20 90-3520
 CIP

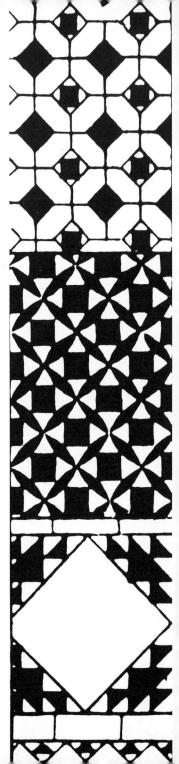

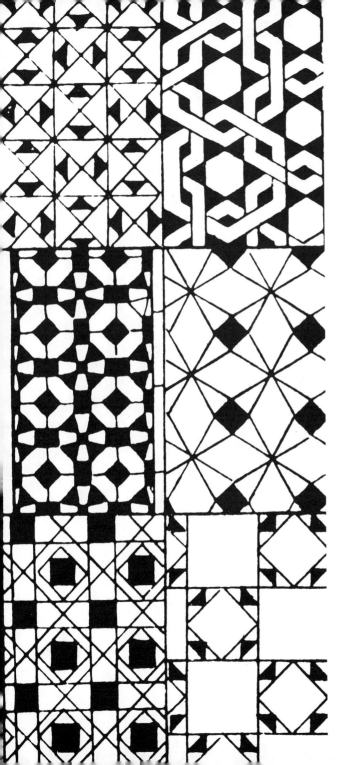

ACKNOWLEDGMENTS

In addition to my teachers and my students, who were of the greatest help, I wish to thank the following persons for their assistance (intentional and otherwise) in preparing this book:

Norma Beale

Louis Dillard

William Eng

Jacqueline Enthoven

Madeline Gyger

LaMar Harrington

Virginia Harvey

Stanley Hess

Eleanor Howard

Mar Hudson

Pauline Johnson

Jennifer Lew

Sterling McIlhany

Nancy C. Newman

Lionel Pries

Mr. and Mrs. Edgar Proctor

Jeannie Swink

Marietta Ward

FRONTISPIECE—Pen drawing by Jennifer Lew.

PAGES 4-7—Diagrams of marble mosaics, St. Mark's, Venice, from Alexander Speltz's *Styles of Ornament,* Dover Publications, Inc., N.Y.

PAGE 134—Detail of textile shown on page 59.

PAGE 136—Star medallion, Iran (Damghan), 13th century. Luster-painted earthenware tiles, 19″ x 18¾″. Courtesy of the Seattle Art Museum, Eugene Fuller Memorial Collection.

ENDPAPERS—Pattern from Edward B. Edwards' *Pattern and Design with Dynamic Symmetry,* Dover Publications, Inc., N.Y. (Endpapers now appear inside the book.)

PREFACE

A wealth of material has been written on design, color, ornament, art history, and every technique imaginable, but little of it comes to grips with the principles of pattern structure. Authors bend over backward to explain the design of beautiful "units," but rarely do they explain the design of beautiful "yardage"—the repetition of units. This book attempts to provide such an explanation, using primarily visual means to illustrate clearly the specific principles of pattern construction, and presenting historical and contemporary design resource material.

The organization of the book is simple and direct. The Introduction provides general information and presents the basic networks on which repeat patterns can be constructed. A brief vocabulary follows; then each network is dealt with in turn. In the concluding chapter, the visual range of a single motif—the Romanesque arch form—is explored by Jennifer Lew, a friend, associate, and former student of the author. Finally, a selected bibliography is provided for the reader who wishes to research the subject of pattern further.

RICHARD M. PROCTOR

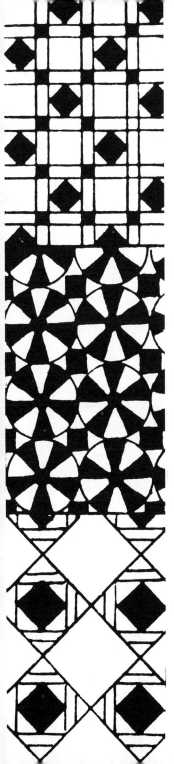

CONTENTS

INTRODUCTION	8
VOCABULARY	9
1. THE SQUARE NETWORK	10
2. THE BRICK & HALF-DROP NETWORKS	24
3. THE DIAMOND NETWORK	32
4. THE TRIANGLE NETWORK	46
5. THE OGEE NETWORK	60
6. THE HEXAGON NETWORK	70
7. THE CIRCLE	84
8. THE SCALE NETWORK	96
9. A CASE STUDY	112
SELECTED BIBLIOGRAPHY	134

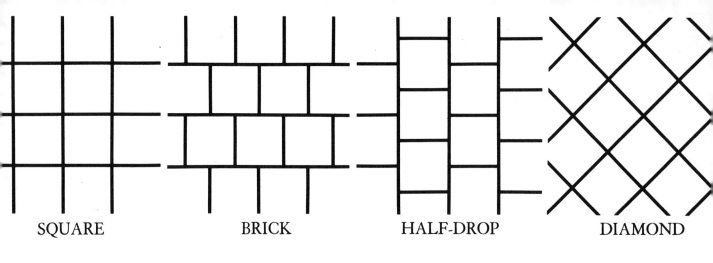

SQUARE BRICK HALF-DROP DIAMOND

INTRODUCTION

Virtually any shape or line repeated often enough will produce pattern of some sort because pattern, by definition, results from the repetition of an element or motif. The system of distribution and the relative detail of the motif determine the apparent complexity of a given pattern. Complexity, however, is no guarantee of quality. A well-proportioned tattersall, for example, is eminently more satisfying than an opulent but awkward arabesque.

Regular, allover pattern requires even distribution and generally follows one of the basic networks diagramed above. Most often these networks form invisible guidelines for the placement of repeat units. Occasionally, networks are not only visible but become an integral part of the finished pattern. Checks, lattice patterns, stripes, and some plaids are obvious examples of this type of network.

You will note that the spaces between the net lines (above) are in fact shapes that will interlock or connect endlessly in any direction. This feature is characteristic of the basic networks; however, it is possible to construct networks in which the shapes do not interlock.

Another aspect of the versatile nature of pattern is its unique ability to exist as both surface and substance. The most obvious role of pattern is in fact that of surface decoration added to enhance an existing product, be it casserole or casement fabric. But pattern can also be a vital part of physical structure. Weaving, knotting, braiding, bricklaying, and even the building of a skyscraper all involve integrating pattern with structure and ornament with function.

Since regular pattern, which is based on the repetition of units at regular, or measured, intervals is the subject of this book, little is said here about irregular, or random, pattern, which is based on unmeasured repetition. It should be mentioned, however, that informal patterns — particularly those from nature — can be very useful to the designer as visual resources.

It should also be noted that the role of color is not discussed. This is not in any way to suggest that color is unimportant to pattern; on the contrary, it could form the subject of an entire book, and the designer will inevitably find it an invaluable and engrossing area to investigate. However, since this book is concerned primarily with the *structure* of pattern, references to color have generally been eliminated on the grounds that it is better to say nothing than too little.

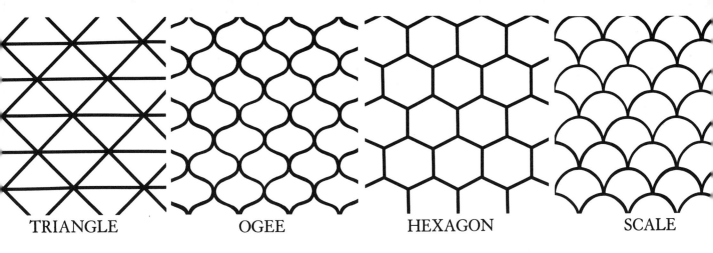

| TRIANGLE | OGEE | HEXAGON | SCALE |

VOCABULARY

A vocabulary of pattern is presented here to familiarize the reader with the basic terms used to describe pattern.

COUNTERCHANGE—A figure-ground reversal (see below) resulting from the superimposition of a line or series of lines on a shape or pattern. The lines (usually checker-like) form the boundaries for alternating colors, textures, surfaces, or other elements.

DIAPER—A pattern or network (see below) of one or more repeating units, constructed in such a way that the outline of each unit forms part of the outline of the neighboring unit. Also, the process of producing or laying out such a pattern.

FIGURE—A form or shape, determined by outlines or exterior surfaces.

FIGURE-GROUND REVERSAL—A pattern or design with roughly equal quantities of two contrasting colors, textures, or other elements, both of which may be perceived as either figure or background.

GRID—A regular network or pattern of (usually straight) lines used to correctly place a pattern on a surface.

INTERLACE—A design in which elements (usually linear) pass over and under each other, producing a complex, woven effect.

INTERVAL—The area or space between recurring elements.

LOZENGE—A four-sided equilateral figure whose opposing angles are equal.

MOTIF—A theme, or dominant recurring visual element, form, or subject.

NEGATIVE SPACE—The background, ground, or space in a composition not occupied by the figure, or major element(s).

NET LINES—The lines (visible or invisible) of any given network. Also, the skeleton of a pattern.

NETWORK—A repeating combination of curved or straight lines; the basic understructure of all repeat patterns. (See also *Diaper*. All networks are diapers, but many diapers are more complex than mere networks.)

PLACEMENT—Location or arrangement of the elements of a pattern.

POSITIVE SPACE—The space in a composition occupied by the figure, or major element(s).

REPEAT—A pattern composed of two or more identical elements, or units.

SCALE—Relative or proportionate size. Also, a figure formed by a network of overlapping circles.

UNIT—The figure that is the basic element of a pattern.

1. THE SQUARE NETWORK

The square or rectangular network is the fairly obvious product of intersecting vertical and horizontal lines or stripes. If the designer produces his pattern by using unembellished net lines of either uniform or varying thickness, a check or plaid is the result. Because we have become a bit jaded by a profusion of tartans and tattersalls, we tend to neglect the endless and rewarding possibilities for these patterns when variables such as color, texture, and scale are considered.

The isolated skeletal system is characterized by strength, order, and simplicity. However, when the square or rectangle becomes the design unit, quite remarkable complexity can be achieved. It does not, in fact, take a virtuoso designer to disguise the unit entirely. Put an X in a square and repeat it enough times, and presto!—a diamond. A corner-to-corner diagonal in a square rotated ninety degrees four times and repeated in groups of four

will yield the same result. Curves or semicircles fitted into square repeat units can produce all manner of scrolls and undulates. Whether the square is treated frankly or deviously as the device for a pattern "game," what really matters is how well the design accomplishes what it sets out to do.

From the examples that compose this chapter, the reader should become aware of at least a fragment of the possible range of elements, devices, and feelings appropriate to the square network.

FACING PAGE—Detail of batik wall hanging by Jennifer Lew. (See page130 for entire piece.)

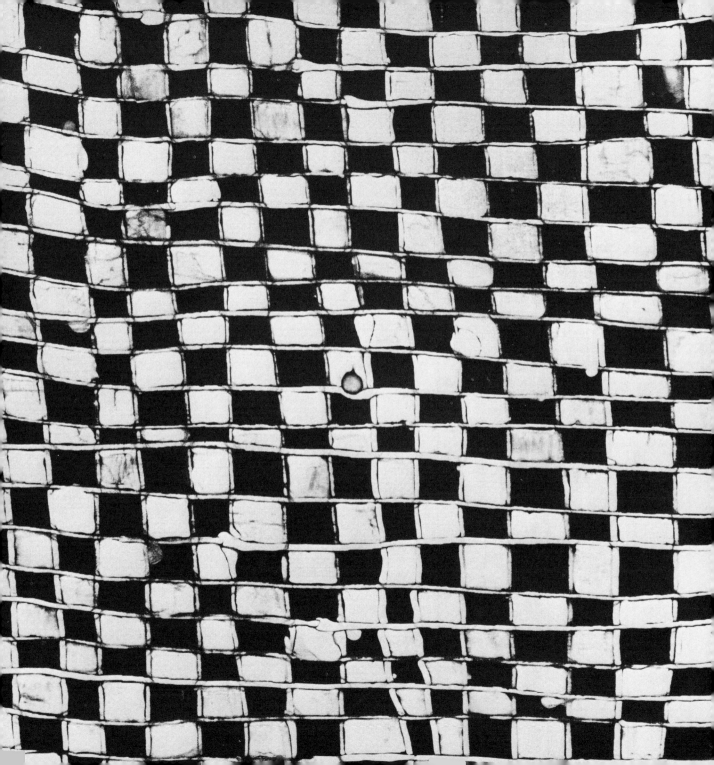

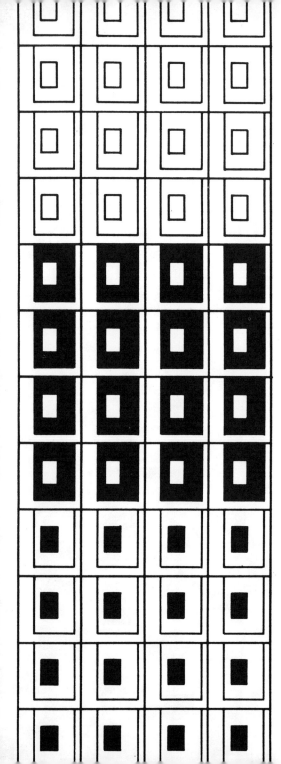

As these studies show, identical units can vary considerably in movement and feeling as a result of contrast alteration. Complete counterchange is used in three of the examples on the facing page (first row, center; second row, left; third row, left). Diagrams by Norma Beale.

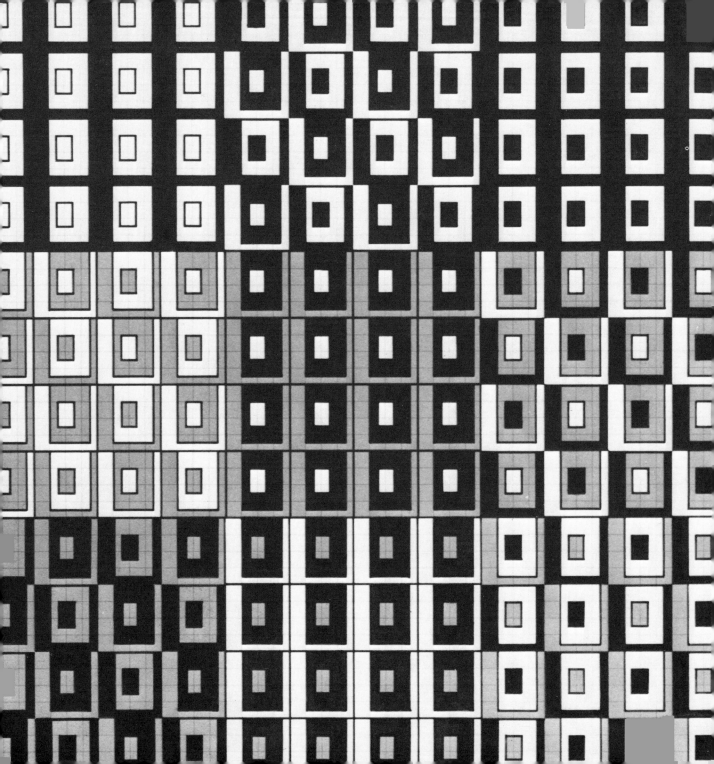

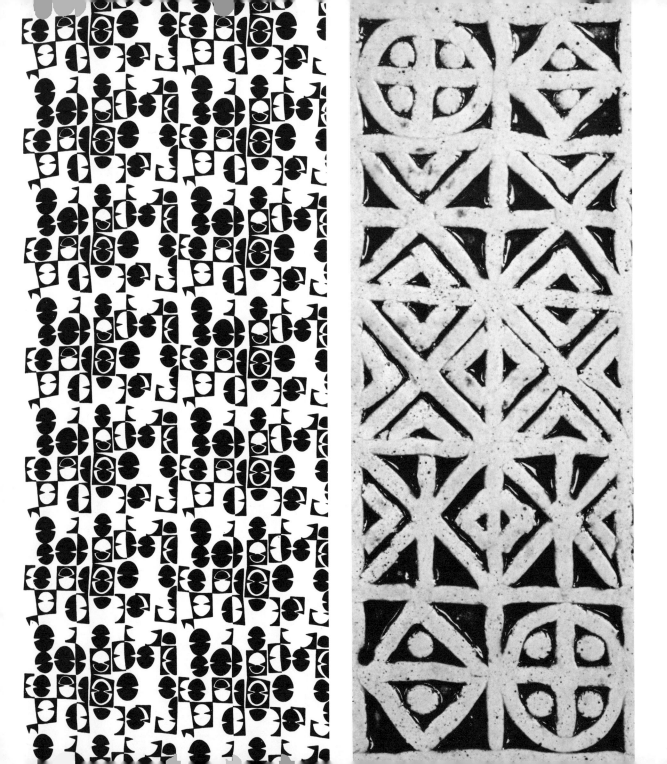

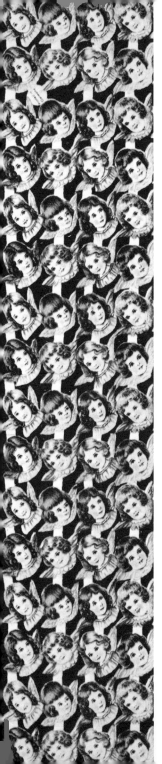

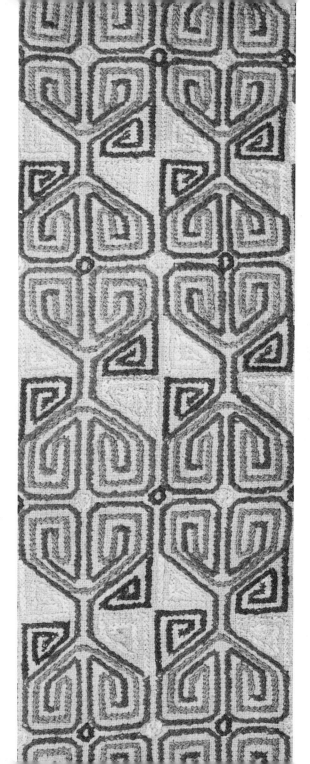

FACING PAGE—*Left:* Screen-printed cotton by the author. Two complex rectangular units cross the textile. *Right:* Detail (front) of ceramic slab bottle by Tom Shafer. Courtesy of The Northwest Craft Center, Seattle.

Left: Gummed paper angels from Germany. Two figures down and four across form the repeating unit. *Right:* Contemporary stitchery by Otomi Indians, Mexico. The larger rectangular units are composed of four smaller mirror-image elements.

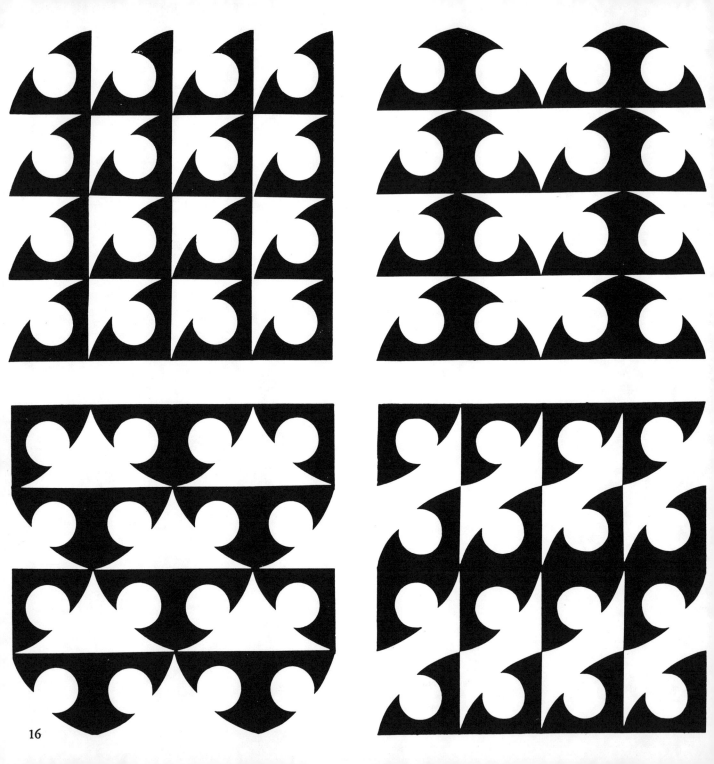

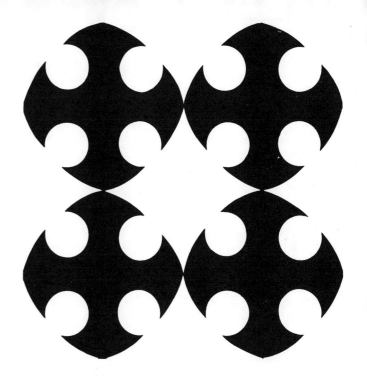

Design project by Norma Beale. In the examples on these two pages, remarkable variety has been achieved by rotating and "flipping" (for a mirror image) a simple quarter-round unit (shown above). It should be noted that the two patterns at right would be identical if they were increased by additional units. (More examples in this series are shown on pages 28, 29, 45, and 69.)

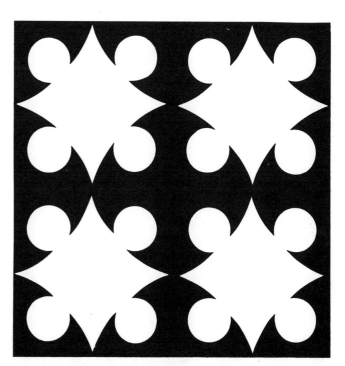

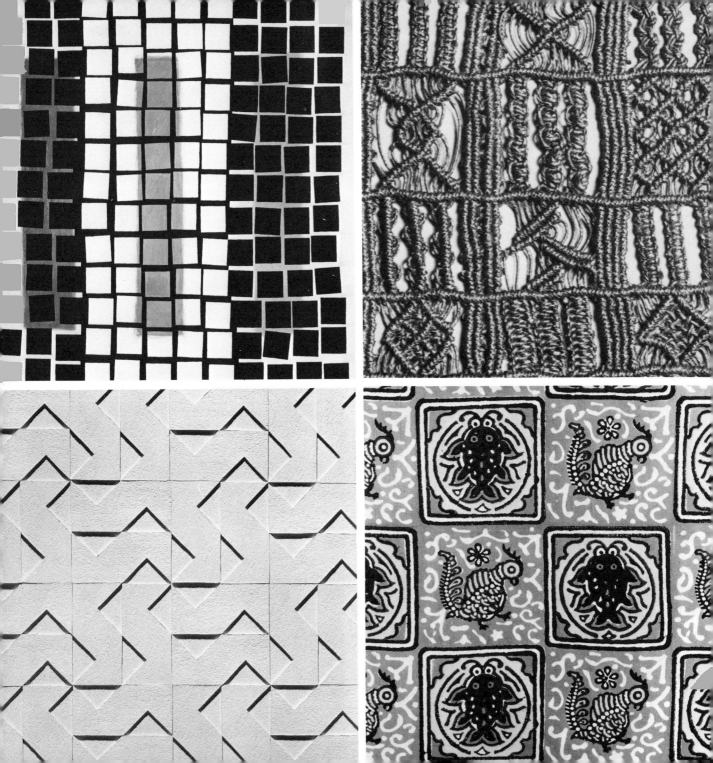

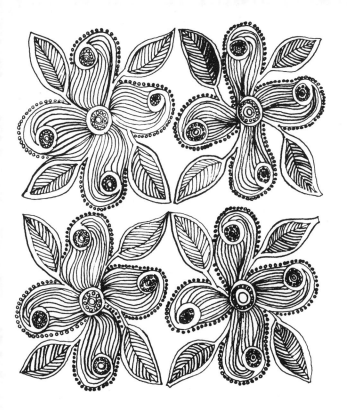

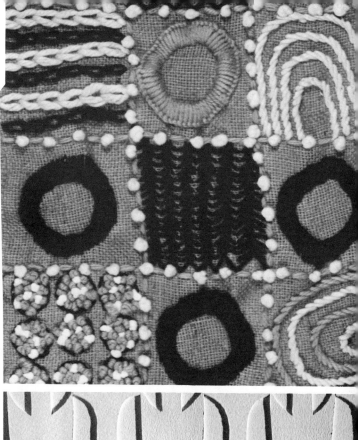

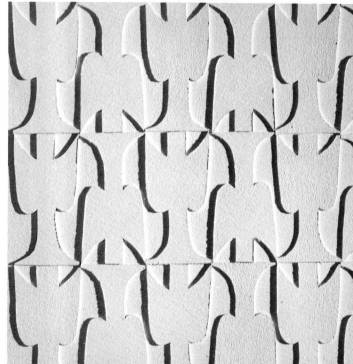

FACING PAGE—*Top left:* "Black Crowds White," by Spencer A. Moseley. Oil on canvas, 1962. *Top right:* Detail of macramé wall hanging by Virginia I. Harvey. *Bottom left:* Paper relief by an adult student of the author. *Bottom right:* Block-printed cotton, Bombay, India. From the Elizabeth Palmer Bayley Textiles of India, Costume and Textile Study Collection, School of Home Economics, University of Washington.

Above left: Ink drawing by Jennifer Lew. *Above right:* Detail of stitchery sampler by Jennifer Lew. *Right:* Paper relief by an adult student of the author.

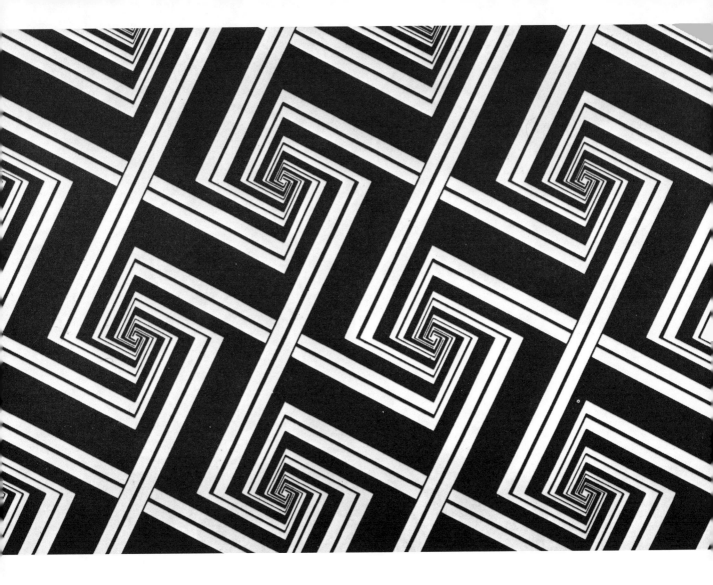

Pattern from Edward B. Edwards' *Pattern and Design with Dynamic Symmetry,* Dover Publications, Inc., N.Y. At first glance, this design appears to be very complex, but once the square unit (shown on the facing page, top left) is located, the rotation repeat becomes obvious. The pattern was calculated mathematically by the use of root-four rectangles and angular logarithmic spirals.

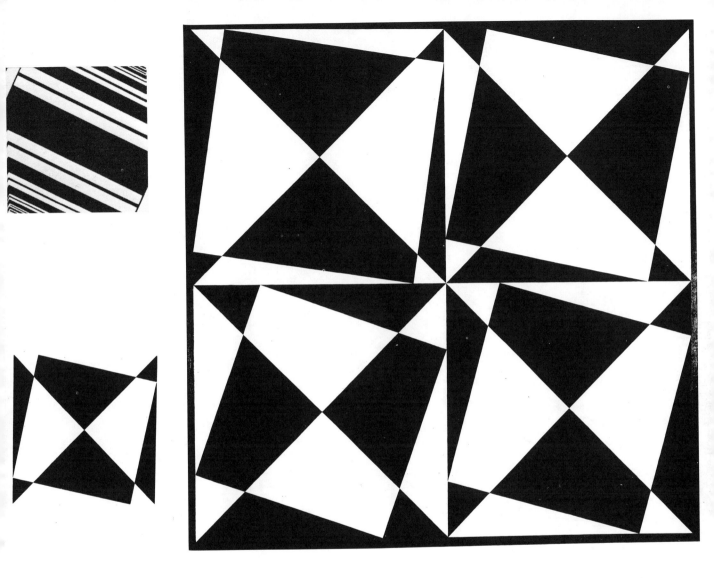

"Conjugation," by the author. Oil on board, 48" x 48", 1965. This painting is based on the gradual rotation of a unit of squares within squares (shown at left above). The larger squares are broken up by Xs, producing a surprising total of fourteen different squares.

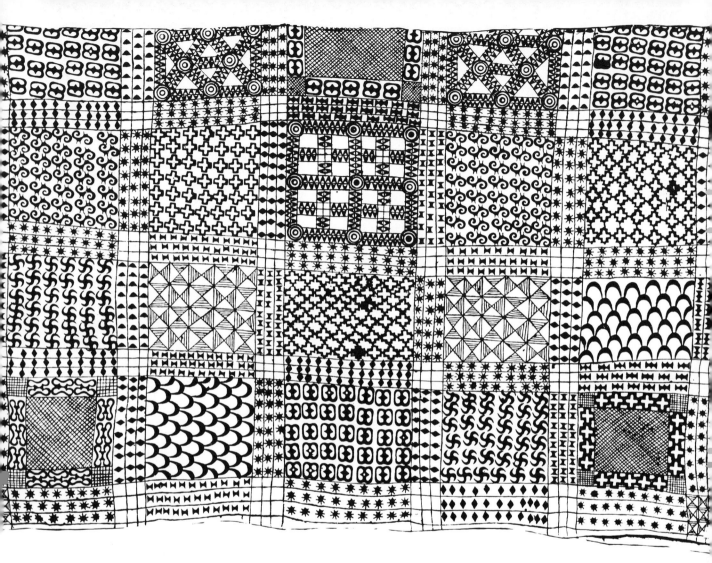

Adinkra cloth, Ashanti tribe, Bonwere
(near Kumasi), Ghana, before 1934.
Courtesy of The British Museum.

FACING PAGE—Poncho, Incan, Peru.
Interlocked tapestry, 72″ x 30¼″. Courtesy
of The Dumbarton Oaks Collection.

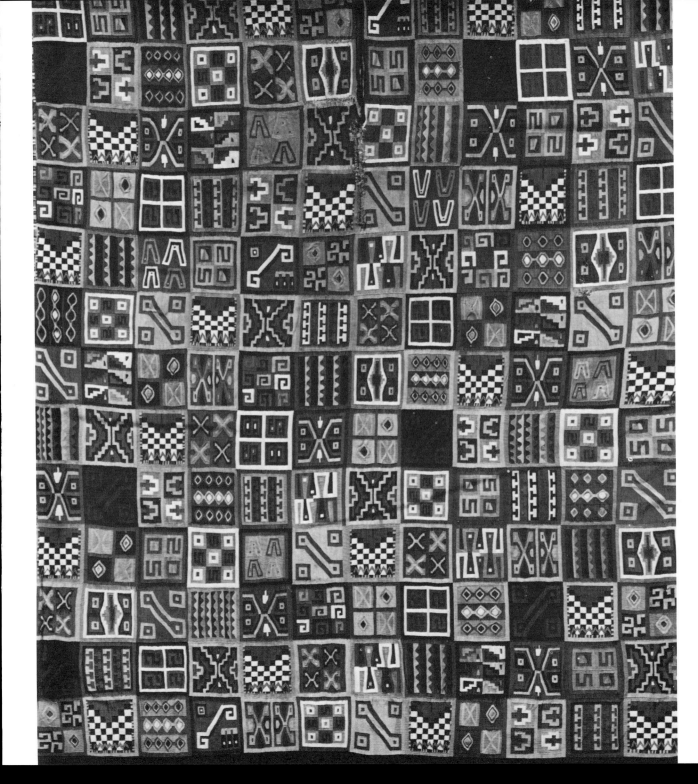

2. THE BRICK & HALF-DROP NETWORKS

The brick and half-drop networks are discussed together because of their close relationship. Both networks are derived from simple variations of square or rectangular unit arrangement. The brick network, as its name implies, results from horizontal alternation, and the half-drop from vertical alternation. It should be quite apparent that rotating either network ninety degrees will produce the other.

Directional movement and the function of the object to be ornamented are the designer's basic criteria for selecting one or the other of these networks. Brick placement simply "looks better" on horizontal forms. Correspondingly, the half-drop is more compatible with vertical forms. This rule of thumb could, however, be reversed should the designer find it necessary to compensate for a structural factor or directional weakness in the surface to be patterned.

Although half-stepping is the conventional proportion for these diapers, it is possible to increase or decrease at will. The quarter-drop, for example, is not uncommon, particularly in printed textiles. By way of caution, it should be noted that counterchange motifs repeated in brick or drop patterns tend to produce strong diagonal stresses. This diagonal emphasis might be considered flattering in apparel goods, but would produce a disquieting tilt on an architectural surface.

Floating or circular motifs diapered to either network usually disguise the skeletal systems and appear to be in diamond or lozenge placement. In fact, diamonds may be made by passing net lines through the exact centers of brick or half-drop units. The examples on page 34 and 35, which deal with the diamond network, illustate the interchangeable nature of much pattern. This seeming ambiguity, common to most networks, may annoy the novice, but it gives a fortunate range and flexibility to the knowledgeable designer.

FACING PAGE—*Top:* Print from a linoleum block, on the brick network, by the author. ***Bottom:*** The same unit printed on a half-drop network. The design is based on an ancient Peruvian stone amulet from the collection of Louella Simpson, Seattle.

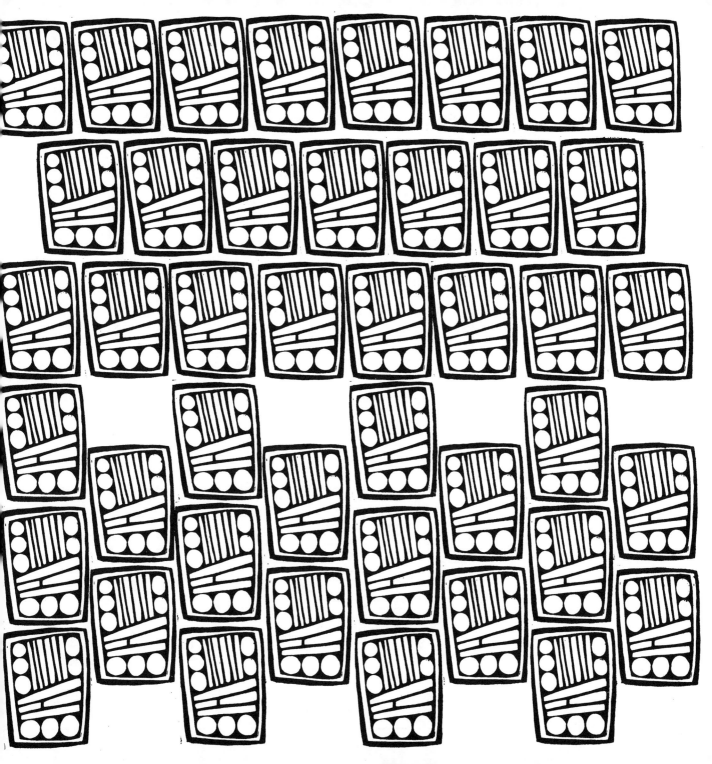

An angular C shape arranged in a variety of combinations. Note that there are many drop and brick network possibilities besides the conventional half-step. Diagrams by Norma Beale.

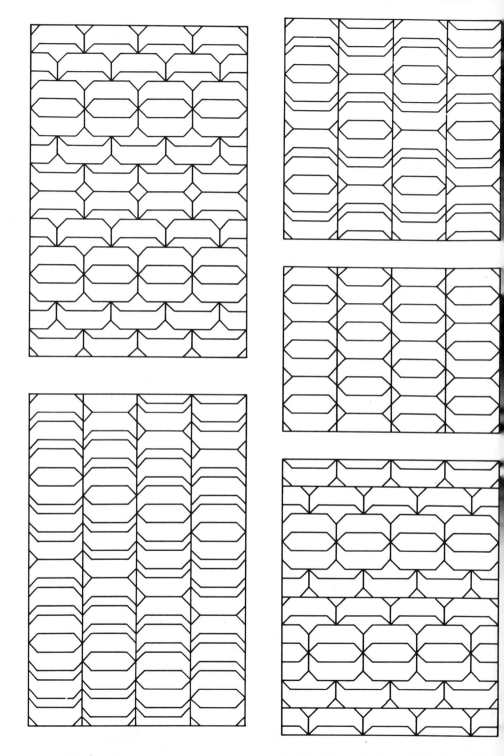

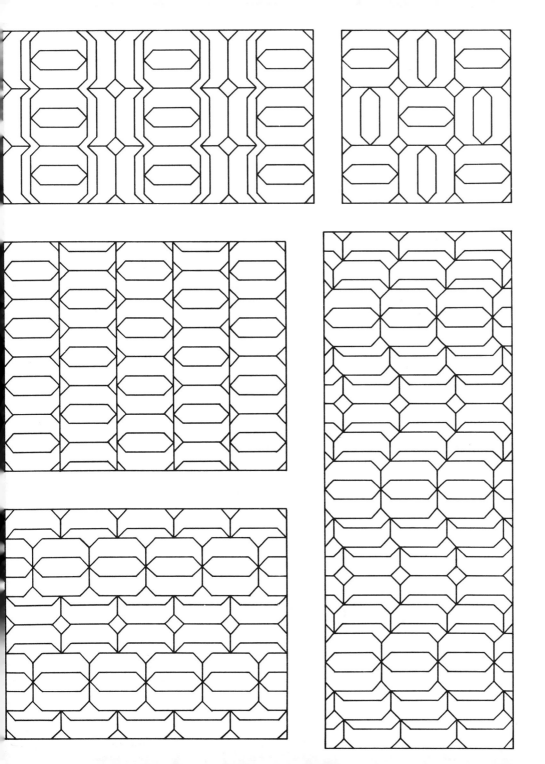

27

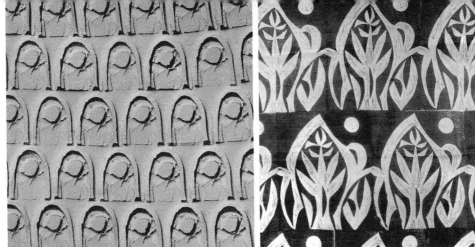

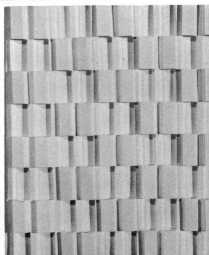

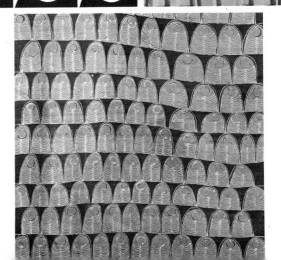

The brick network.

FIRST ROW—*Left:* Clay tile stamped with carved eraser by Jennifer Lew. *Right:* Block-printed textile by Jane Gehring. Courtesy of the Henry Art Gallery, University of Washington.

SECOND ROW—*Left:* Contemporary wrapping paper. *Center:* Cut-paper design by Norma Beale. *Right:* Scored, cut, and folded paper design by a student of the author.

THIRD ROW—Detail of batik wall hanging by Jennifer Lew.

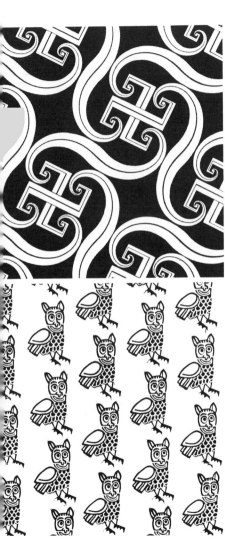

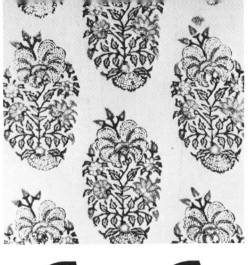

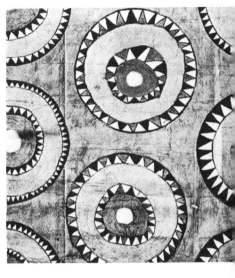

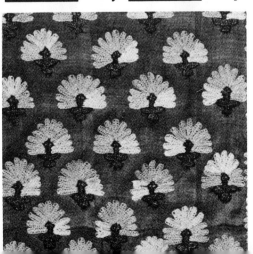

The half-drop network.

FIRST COLUMN—*Top:* Drop pattern from Edward B. Edwards' *Pattern and Design with Dynamic Symmetry*, Dover Publications, Inc., N.Y.
Bottom: Block-printed cotton.

SECOND COLUMN—*Top:* Block-printed turban, muslin, Rajasthan State, India, 19th century or earlier. This and the baby pillow (see below) are from the Elizabeth Palmer Bayley Textiles of India, Costume and Textile Study Collections, School of Home Economics, University of Washington. *Center:* Cut-paper design by Norma Beale. *Bottom:* Embroidered baby pillow, Sindh, West Pakistan.

THIRD COLUMN—Hawaiian tapa. Courtesy of the Peabody Museum, Salem, Massachusetts.

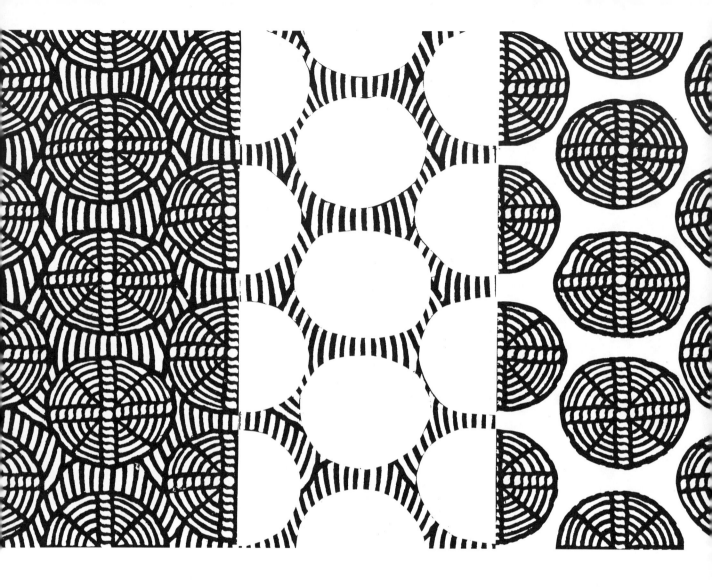

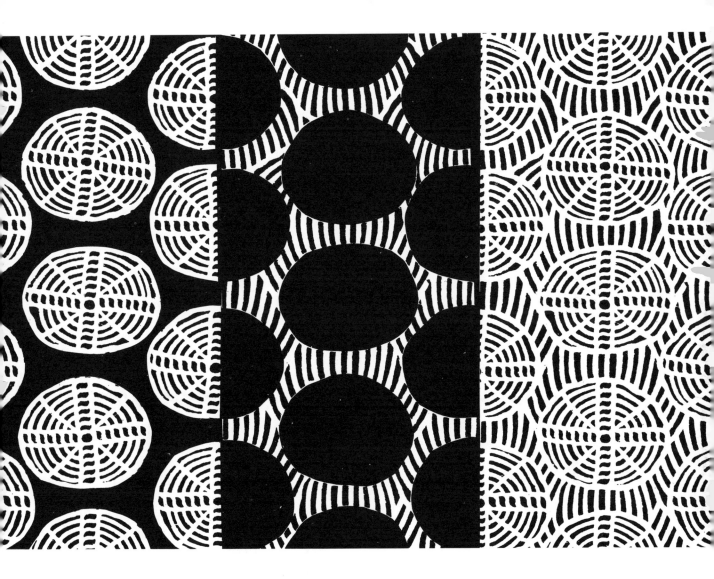

Above: Photo-collage by the author, showing variations on a simple Japanese half-drop stencil design (shown on the facing page). Note the similarity of the half-drop to the diamond placement.

3. THE DIAMOND NETWORK

The true diamond is a perfect square rotated forty-five degrees from the horizontal so that it stands on the point of a corner, but in common usage the term "diamond" is used interchangeably with "lozenge" and "rhombus" (an equilateral parallelogram in which one pair of angles is oblique).

Individually, diamond or lozenge units tend to have a feeling of lightness, delicacy, and impending movement. Grouped on their own net lines, however, they are capable of conveying radical extremes of visual weight.

As a network for techniques such as block printing, the diamond is a very useful diapering system because so many other units fit its net lines. Triangles are the obvious candidates, but appropriate registration marks on a printing block will permit ogees, hexagons, and scales to be printed accurately. When circles are repeated in the centers of diamond grids, they will appear to be in perfect half-drop formation. As indicated previously, this "hopscotching" of units and networks is a distinct design advantage.

No single culture or historical period has had a monopoly on any network or repeat unit. Aboriginal craftsmen, however, have made such repeated and powerful use of the diamond and its related triangles, chevrons, and zigzags that the association is unavoidable (see, for example, the illustrations on pages 40, 41, and 58).

FACING PAGE—Detail of macramé wall hanging by Virginia I. Harvey.

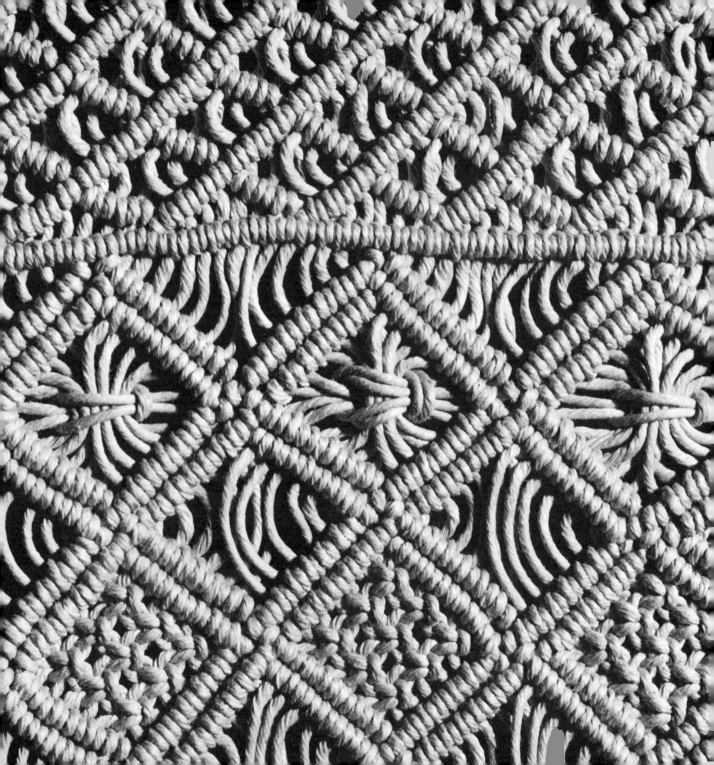

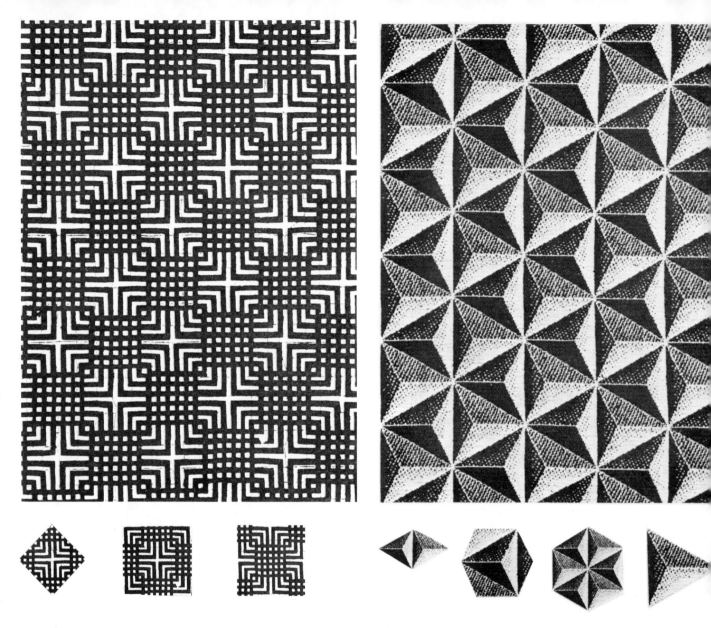

The examples on these two pages demonstrate how exactly the same pattern may be achieved with different units and even different networks. The diamond network is common to all.

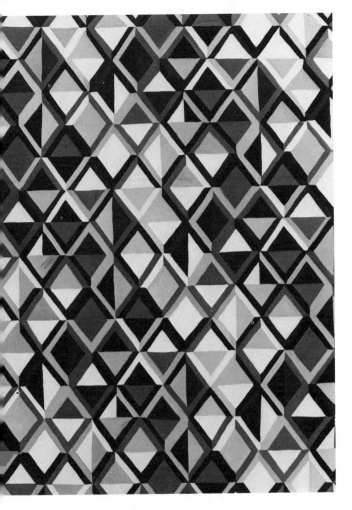

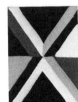
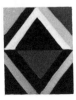
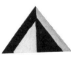

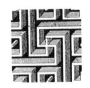
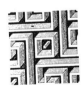
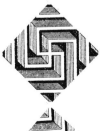
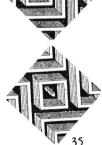

FACING PAGE—*Top left:* Japanese stencil design intended for textile use. *Top right:* Woven textile from Italy, 20th century. Collection of Betty Jensen, Seattle.

Above left: Design project by an adult student of the author. Gouache on paper.
Above right: Drawing of Pompeiian mosaic. Reprinted from *Polychrome Ornament* by Albert Racinet, London, 1877.

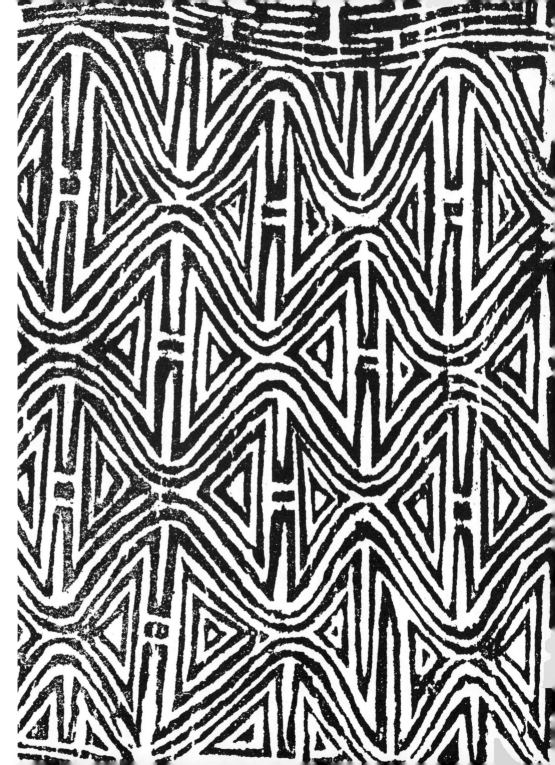

Rubbing of incised spear design from the north coast of New Guinea. Courtesy of the Field Museum of Natural History, Chicago.

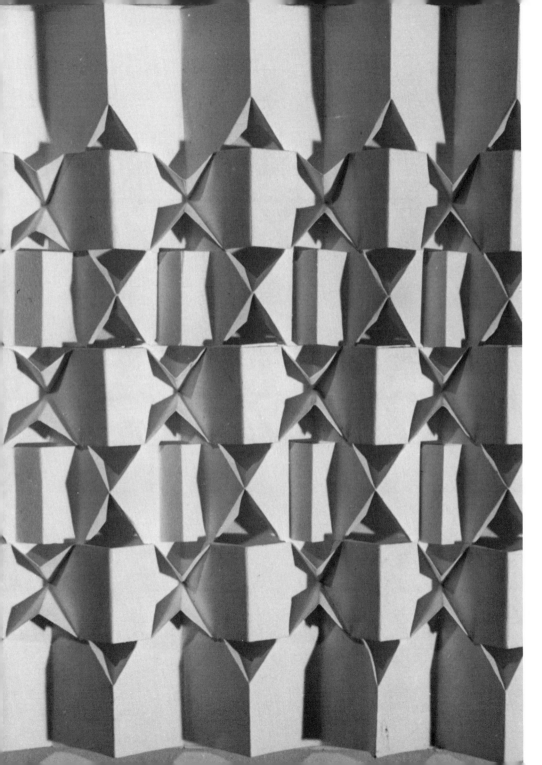

Scored, cut, and folded
paper design by an adult
student of the author.

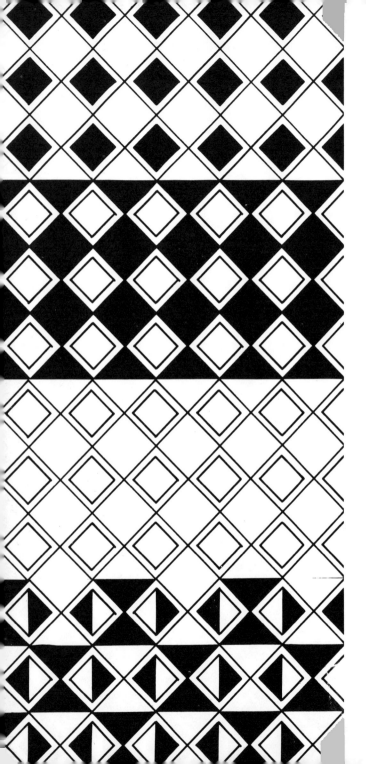

A small diamond shape floating within diamond net lines is the compositional basis for the series of patterns on these two pages. Embellishment and dark-light alternation are the designer's means of achieving variety. Diagrams by Norma Beale.

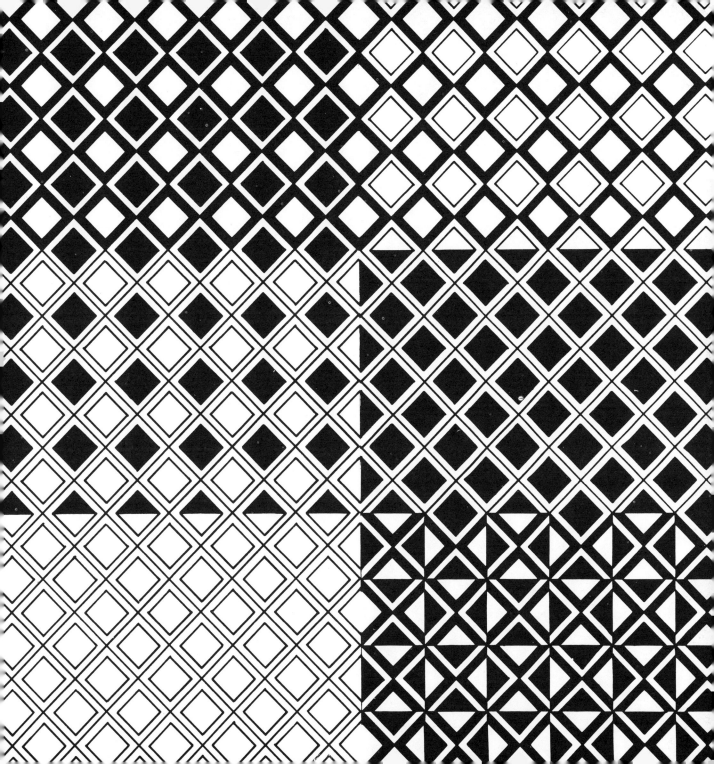

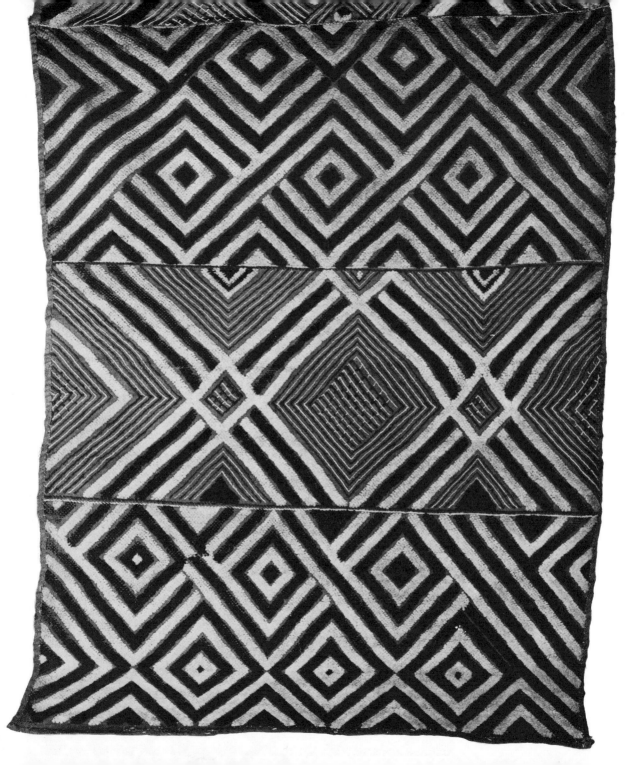

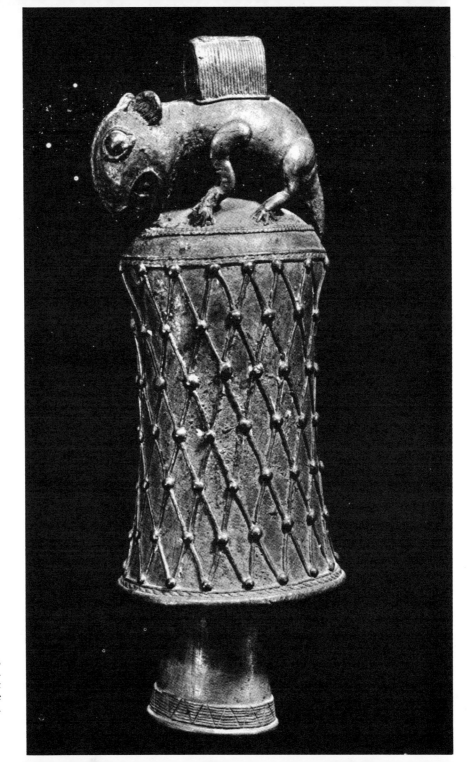

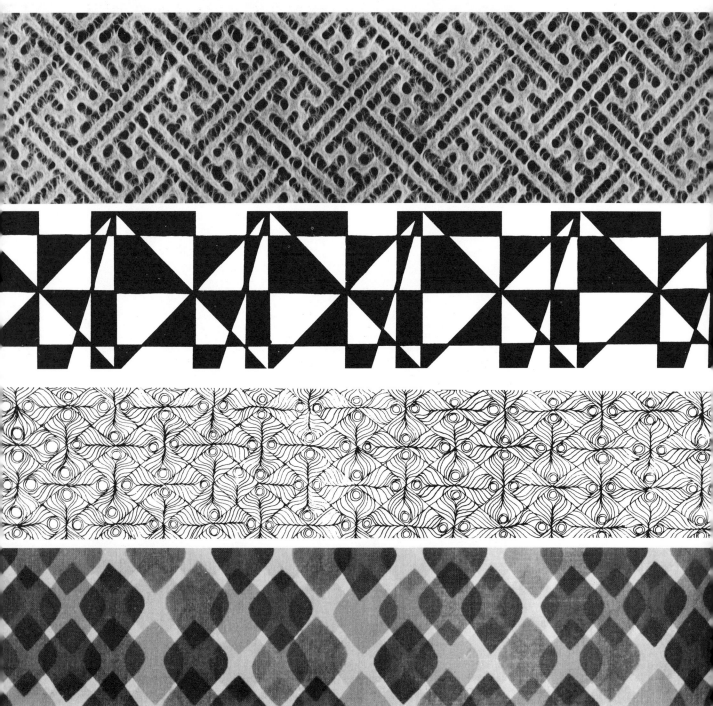

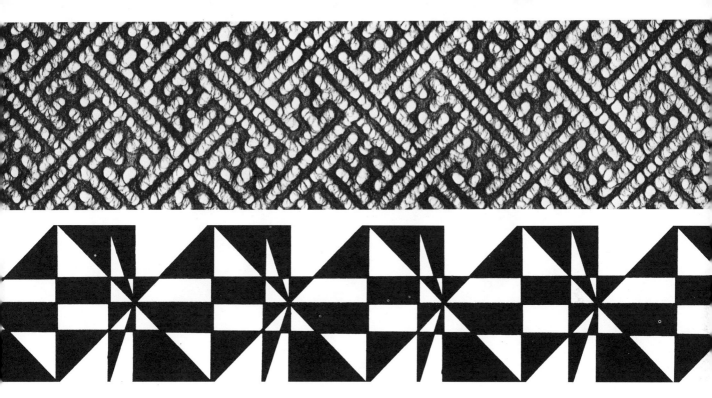

First row: Japanese patterned rice paper and photographic reversal of the pattern.
Second row: Design problem by a student of the author.
Third row: Pen drawing by Jennifer Lew.
Fourth row: "Feathers," screen-printed linen drapery fabric designed by Alexander Girard. Courtesy of Herman Miller, Inc.

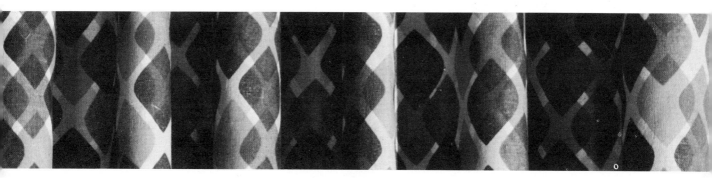

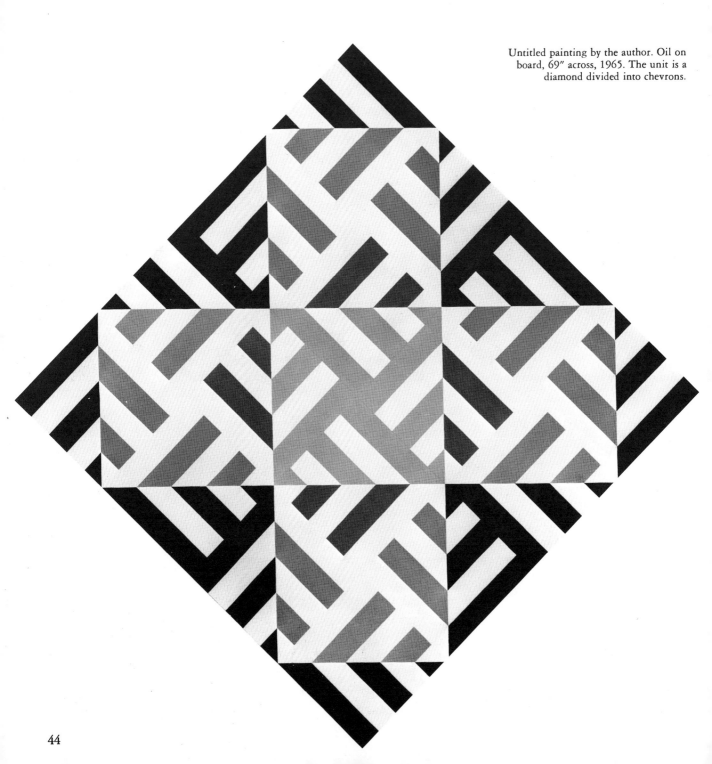

Untitled painting by the author. Oil on board, 69" across, 1965. The unit is a diamond divided into chevrons.

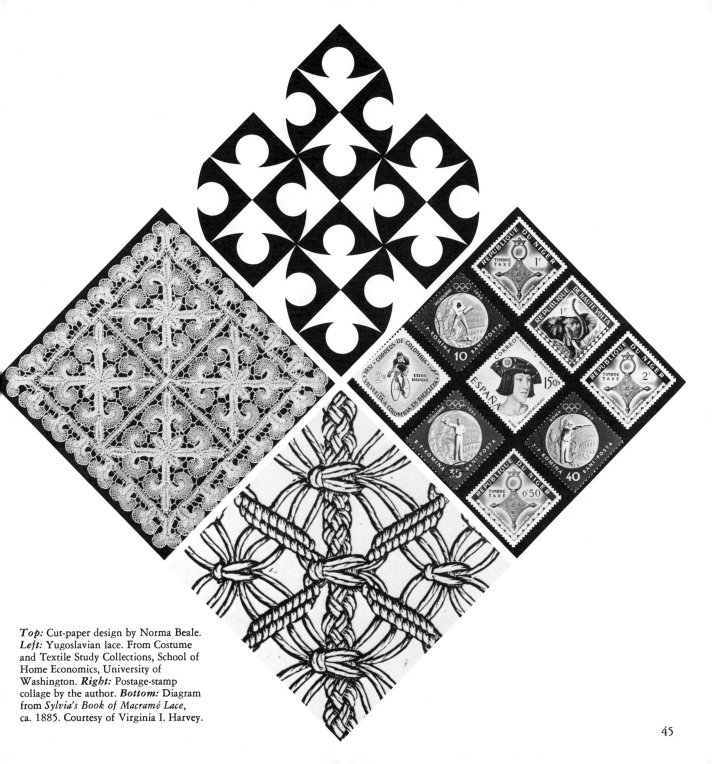

Top: Cut-paper design by Norma Beale.
Left: Yugoslavian lace. From Costume
and Textile Study Collections, School of
Home Economics, University of
Washington. *Right:* Postage-stamp
collage by the author. *Bottom:* Diagram
from *Sylvia's Book of Macramé Lace,*
ca. 1885. Courtesy of Virginia I. Harvey.

45

 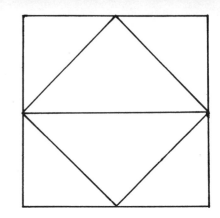

4·THE TRIANGLE NETWORK

As a network in the strictest sense, the triangle diaper is little more than a divided diamond, but a triangular design unit is possibly the most versatile shape at the pattern designer's disposal. Depending on their relative proportions, triangles can be assembled to form squares, rectangles, parallelograms, hexagons, octagons, and even somewhat "lumpy" circles (see overleaf).

Because of the amazing flexibility of the triangular unit, it is a good idea to test its repeat relationship about midway in the designing process. Stamp printing with an eraser, a linoleum block, or even a potato is a quick and convenient means of visualizing the assets and liabilities of a pattern idea. This is true of any repeat unit regardless of its network, and especially so of units with strong directional lines or with shapes that run off the edge of the design area. (The reader is directed to the Bibliography for information on stamp and block printing.)

The architectural and engineering applications of the triangle are obvious and serve as constant reminders of the structural and visual importance of this network. Triangles are the basic components of most polyhedrons (see page 52) and lend themselves to bold counterchange or mirror-image embellishment. Whether used two- or three-dimensionally, the triangle is consistently characterized by strength and movement.

FACING PAGE—Batik wall hanging designed by the author. Approximately 18″ x 18″.

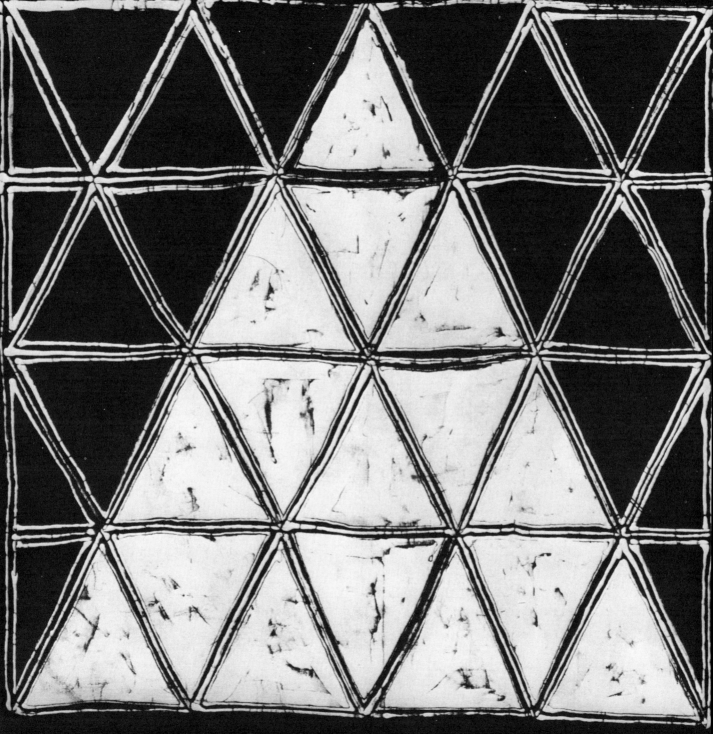

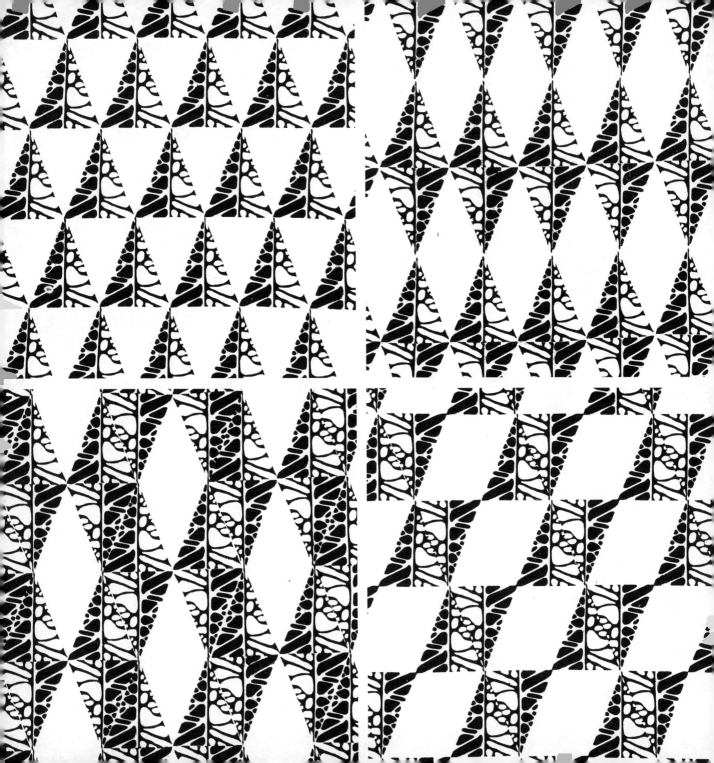

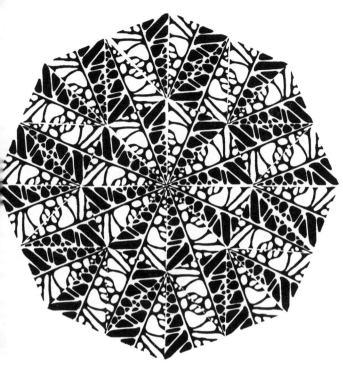

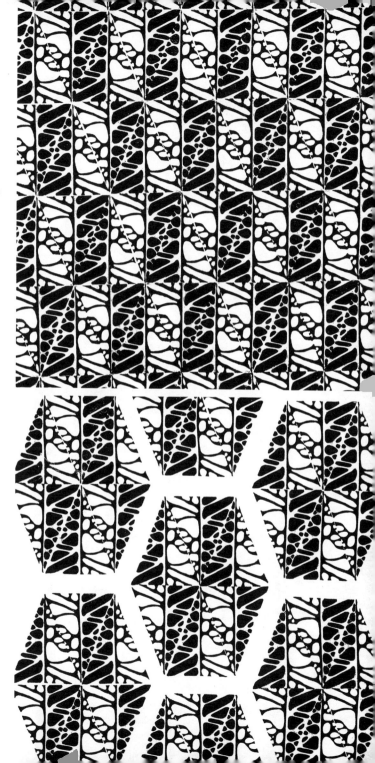

A series of linoleum-block-printed textile samples by a student of the author.

FACING PAGE—*Top left:* True triangle network with alternate spaces unprinted. *Top right:* The same triangle network with positive and negative diamonds. *Bottom left:* Triangle network with units making vertical zigzags. *Bottom right:* Parallelograms formed on the same network.

Above left: A near-circle printed with the same block. *Above right:* Triangle network completely fitted. *Right:* Groups of six triangles printed as hexagons.

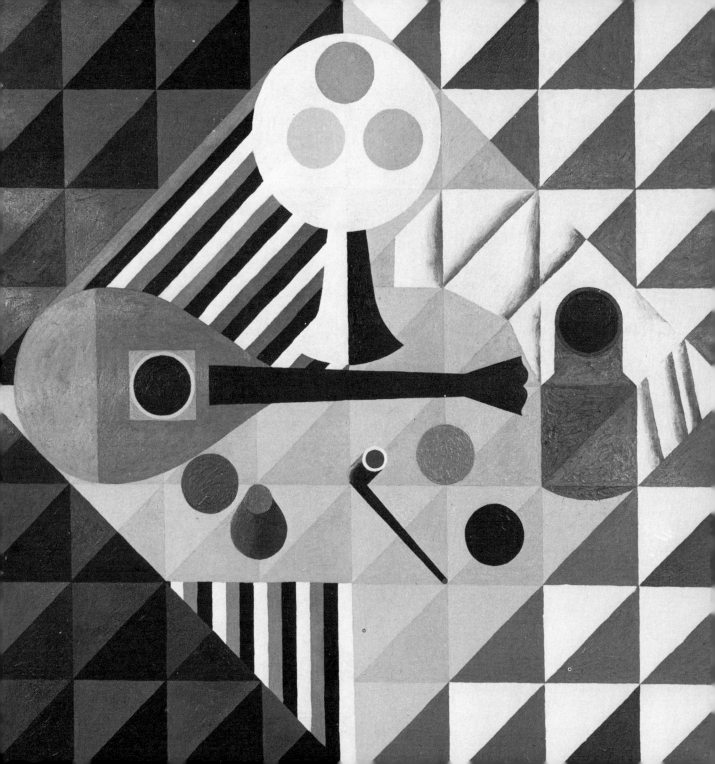

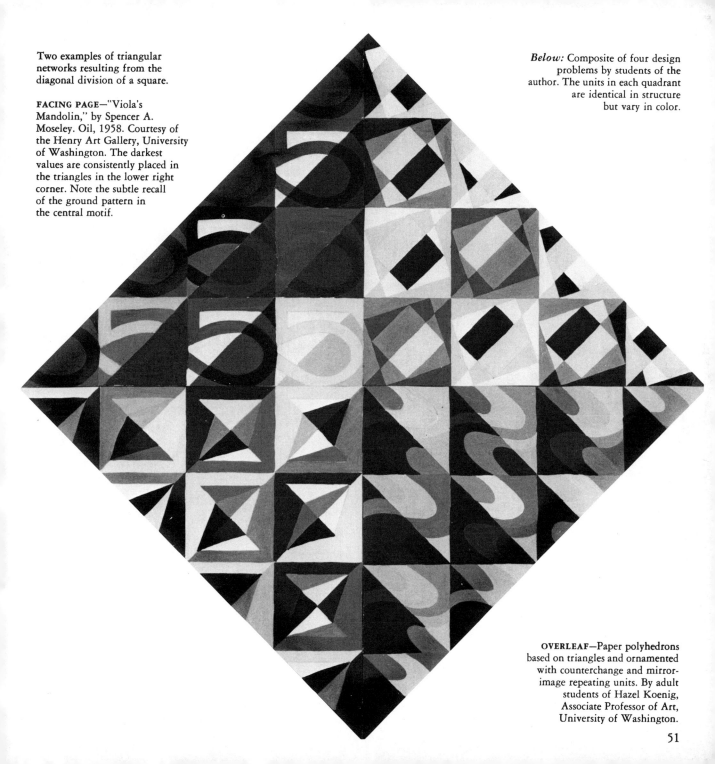

Two examples of triangular networks resulting from the diagonal division of a square.

FACING PAGE—"Viola's Mandolin," by Spencer A. Moseley. Oil, 1958. Courtesy of the Henry Art Gallery, University of Washington. The darkest values are consistently placed in the triangles in the lower right corner. Note the subtle recall of the ground pattern in the central motif.

Below: Composite of four design problems by students of the author. The units in each quadrant are identical in structure but vary in color.

OVERLEAF—Paper polyhedrons based on triangles and ornamented with counterchange and mirror-image repeating units. By adult students of Hazel Koenig, Associate Professor of Art, University of Washington.

51

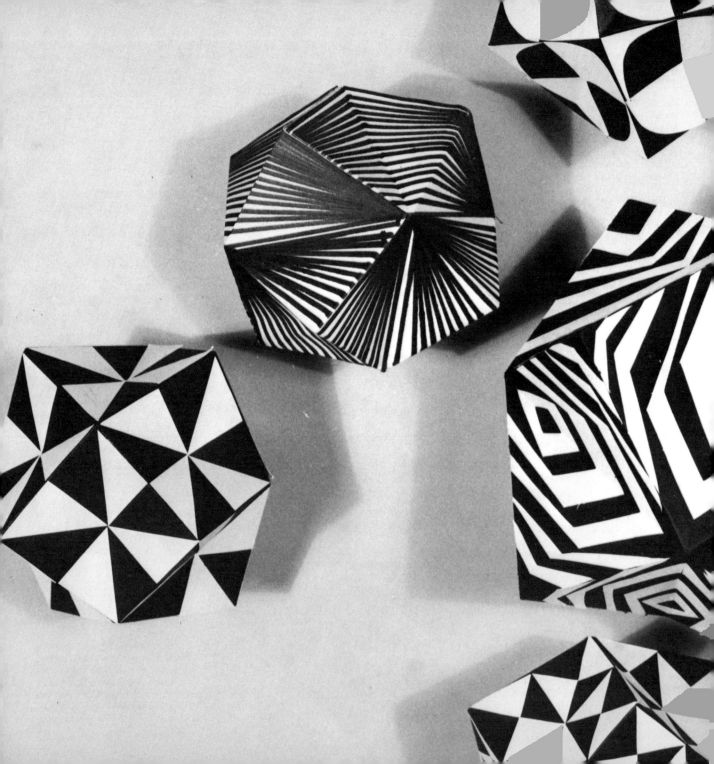

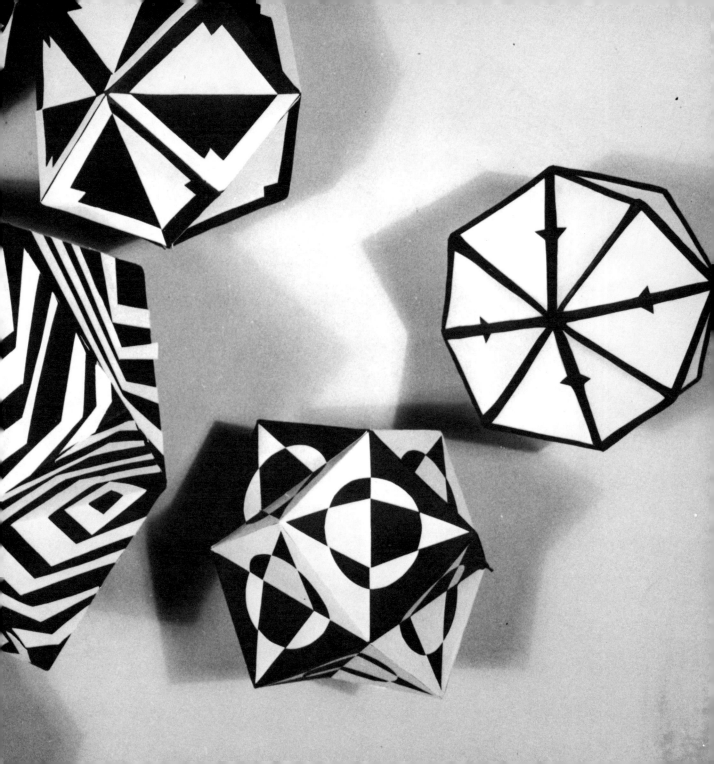

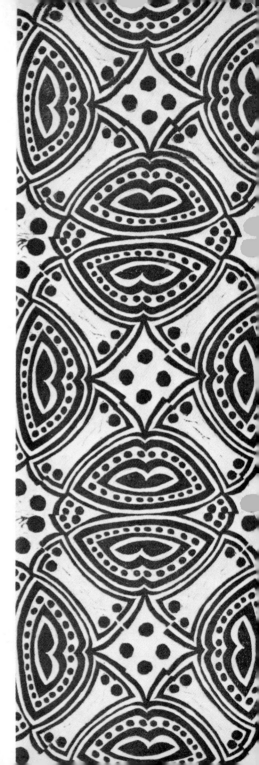

The carved linoleum printing block above is a triangle whose base is twice the length of its height. When such a triangle is rotated four times around a point, a square is produced. The block-printed textile at right is composed of six of these square units. The decorative paper reproduced on the facing page, far right, was first folded into squares and then into triangles. These triangles were decorated with the same design as the linoleum block. All examples by Jennifer Lew.

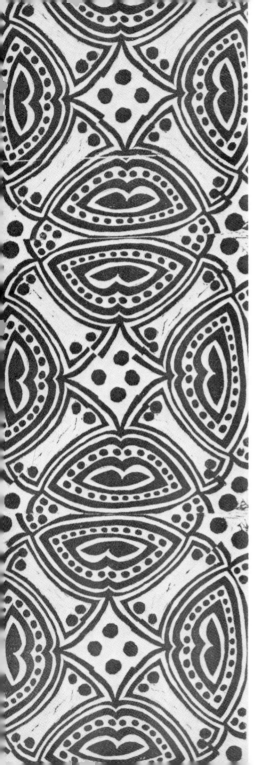
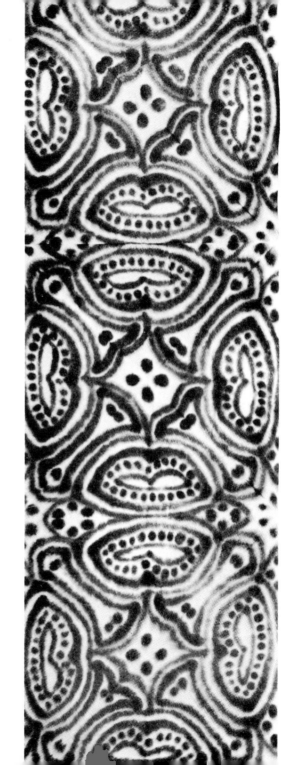

55

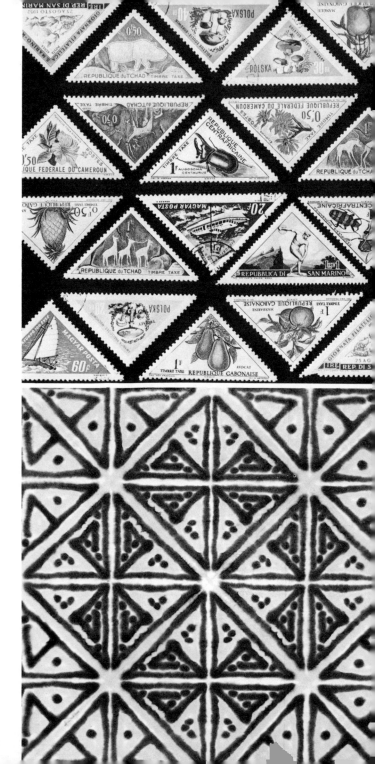

Top right: Pattern formed with
triangular postage stamps by the author.
Bottom right: Fold-dyed silk span
(model airplane) paper by the author.

FACING PAGE—*Top:* "Grid," screen-
printed linen designed by Alexander
Girard. Courtesy of Herman Miller, Inc.
Bottom: Detail of batik apparel
yardage made by the author.

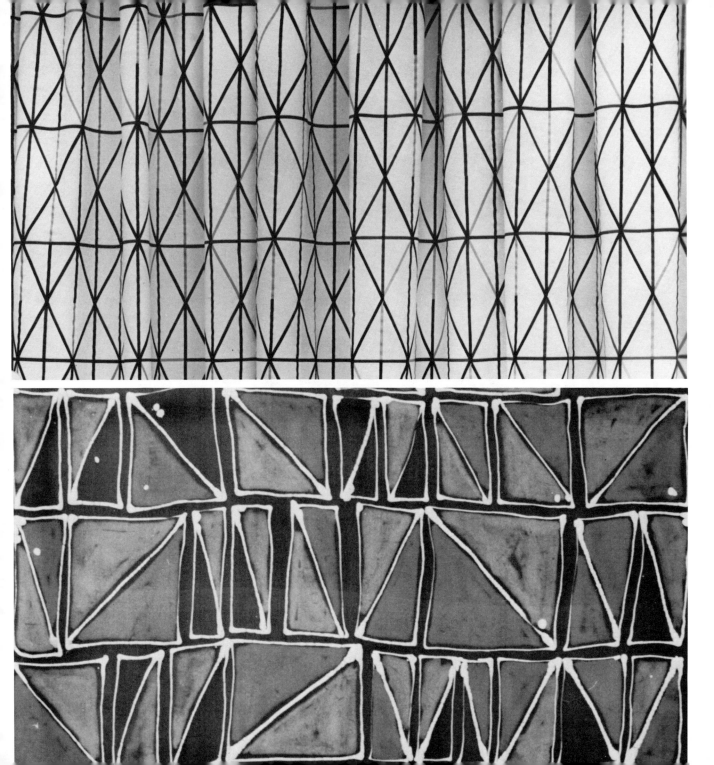

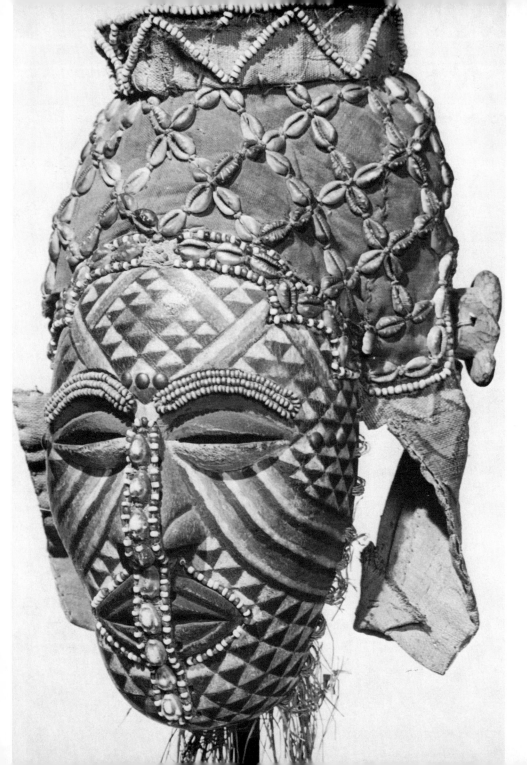

Mask of wood, Bushongo tribe, Central Congo. Polychrome, with beads, shells, and raffia cloth, 13½" high. Courtesy of the Baltimore Museum of Art, Wurtzburger Collection of African Art.

FACING PAGE—"Pythagoras," screen-printed fabric designed by Sven Markelius. Courtesy of Knoll Textiles, Division of Art Metal-Knoll Corporation.

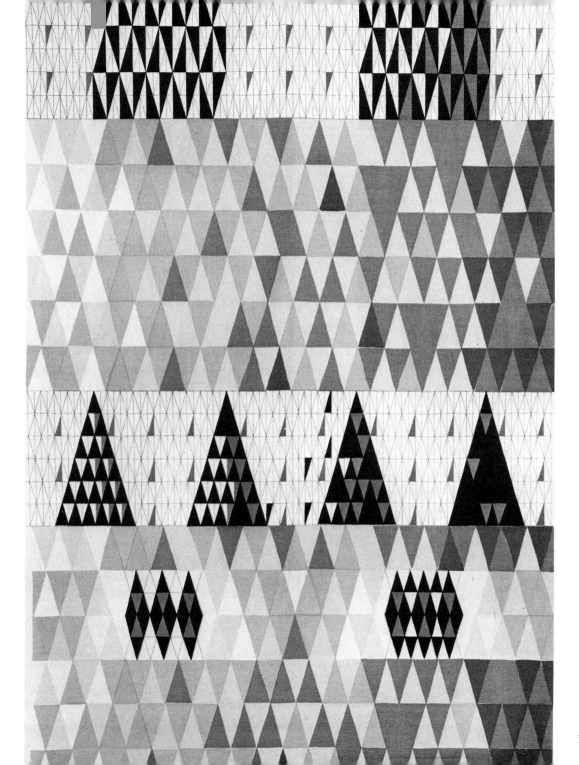

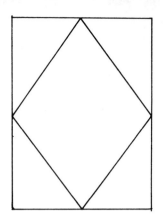 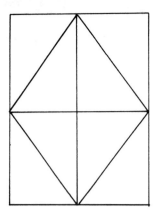 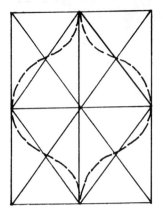 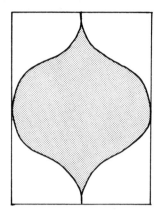

5 · THE OGEE NETWORK

The graceful ogee is derived from the lozenge or diamond, as can be seen in the diagram above. The ogee is a figure based on the S curve, combining both concave and convex contours. By superimposing a properly adjusted network of such wave lines on a lozenge diaper, the ogee network emerges. Ogees may be vertical, like glass Christmas ornaments, or horizontal, like stretched fishnet. The object is to make the shapes fit the contours of the neighboring ones without leaving awkward slivers of space between. The sine curve is another, mathematical means of arriving at the ogee network.

Because of their undulating outlines, ogee forms lend themselves especially to curved embellishment. It is possible to integrate some angularity into an ogee unit, but one composed entirely of sharp angles would look incon-gruous. The appropriateness of ogee curves is historically precedented by the profusion of graceful vines, stems, and tendrils that have been placed on ogee networks.

The ogee network offers the designer little choice of unit placement, but variety can be achieved by overlapping (see page 66) or by providing "breathing space" between motifs. The notched ogee, an example of which is shown on page 69, is one of several interesting hybrids; it is similar to the "Spanish tile shape" much used by Hispano-Moresque craftsmen.

FACING PAGE—Photostat collage (reduced) of a drawing by
Jennifer Lew. Ink on tracing paper.
Adaptation of a Coptic textile depicting the Tree of Life.

60

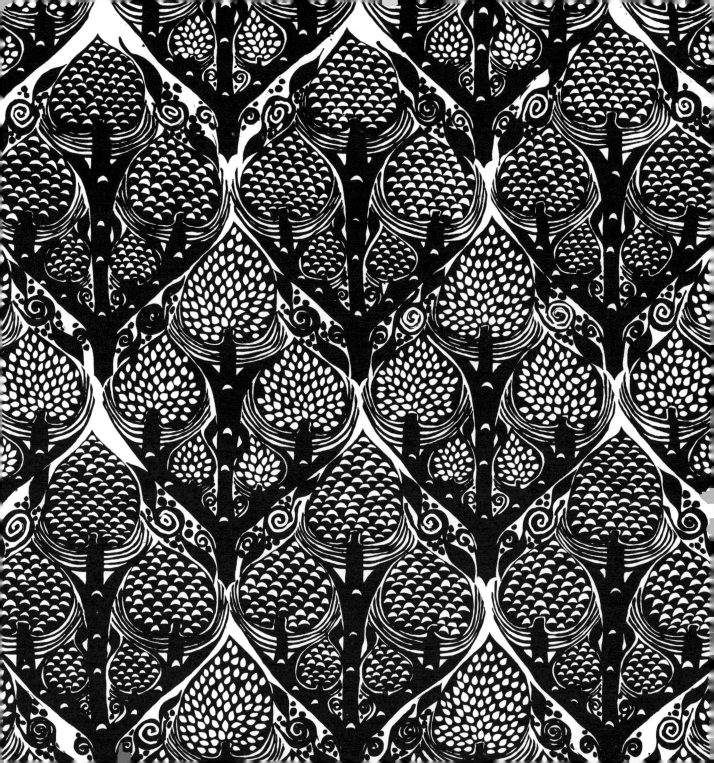

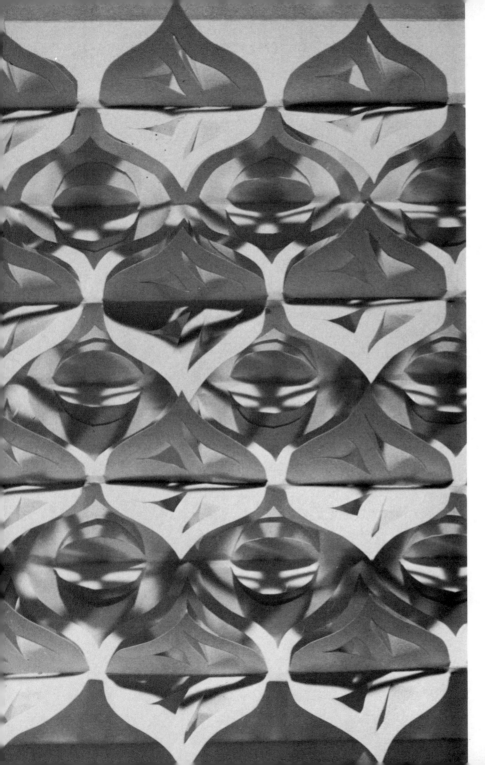

Scored, cut, and folded paper design project by a student of the author.

FACING PAGE—*Left:* A piece of drawing paper with alternating vertical slits was expanded horizontally to produce this ogee network. *Right:* "Siwana/casa," printed sheer fabric with seemingly random ogee placement. The unit is actually a complex repeating rectangle. Courtesy of the manufacturer, David and Dash, Miami.

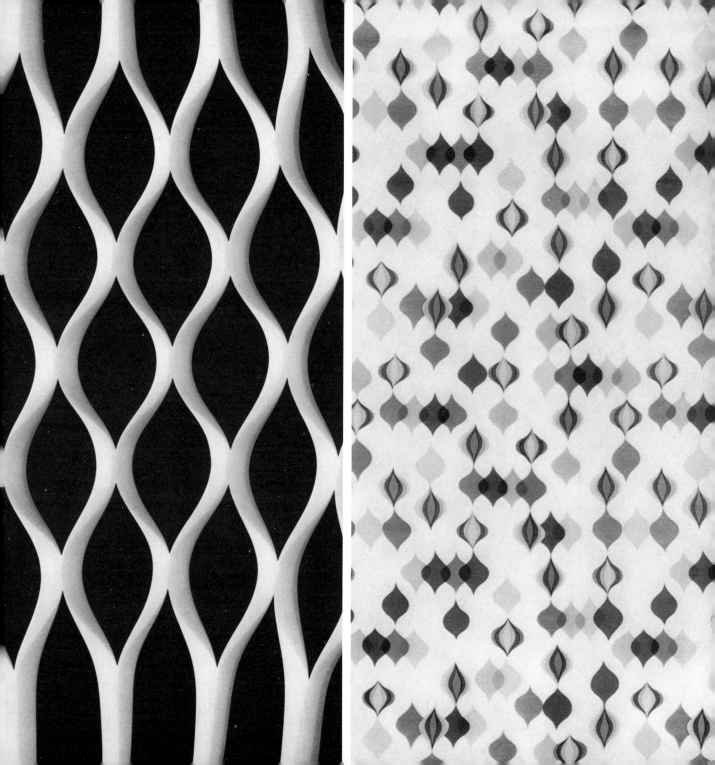

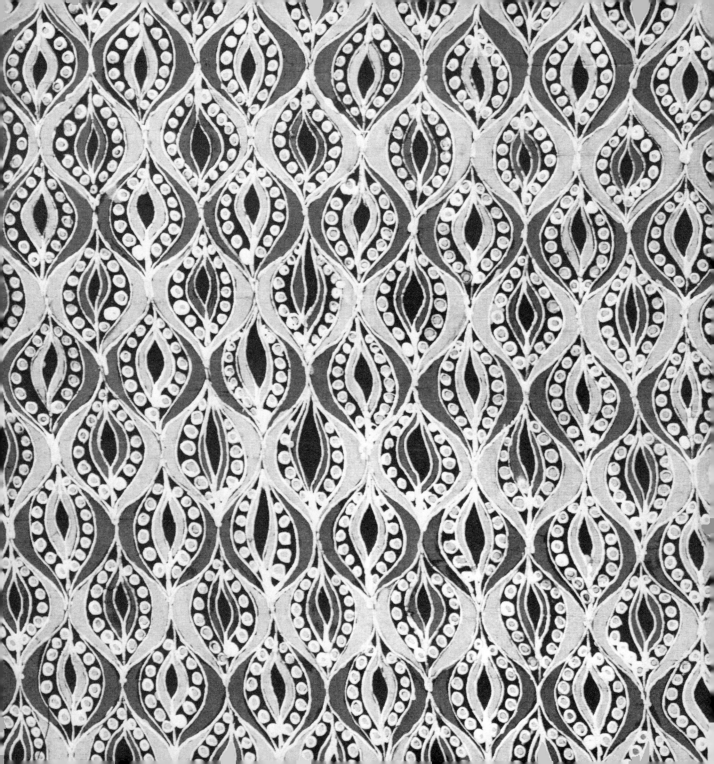

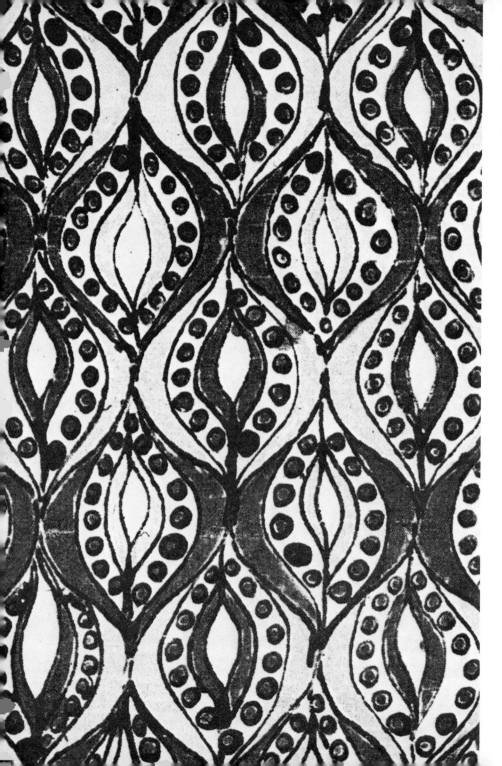

FACING PAGE—Detail of batik test piece by Jennifer Lew. The horizontal bands of alternately dark and light value give variety to this design, while the centers of the ogee motifs are uniform, providing an overall unity.

Left: Photographically reversed and enlarged detail of the batik.

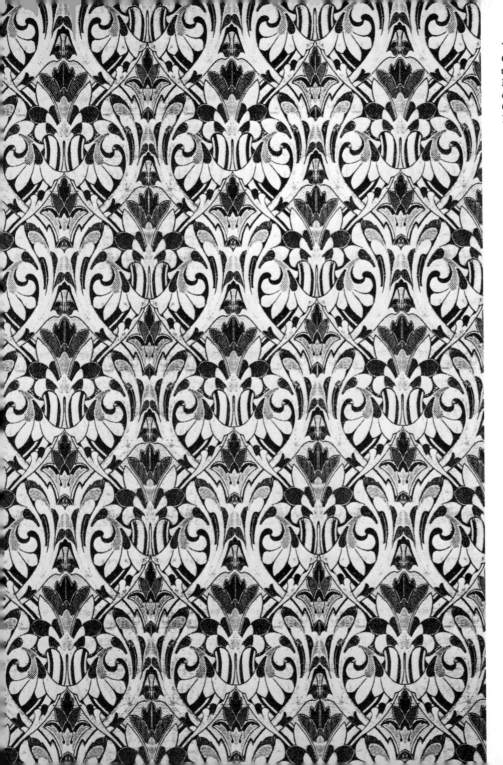

"L'Opera," wallpaper designed by H. Crane Day. A skillful adaptation of a textile in the Victoria and Albert Museum, London. Note the subtle overlapping of two ogee networks. Courtesy of the manufacturer, Winfield Design Associates, Inc., San Francisco.

FACING PAGE—Page from a designer's sketchbook. Courtesy of Jennifer Lew. Note the way in which four scale units join to form an ogee in the center design.

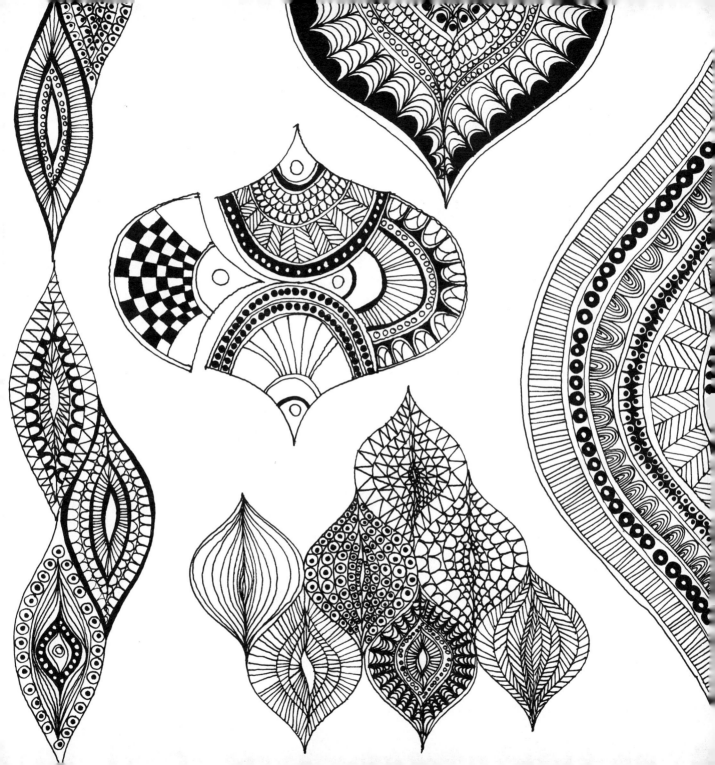

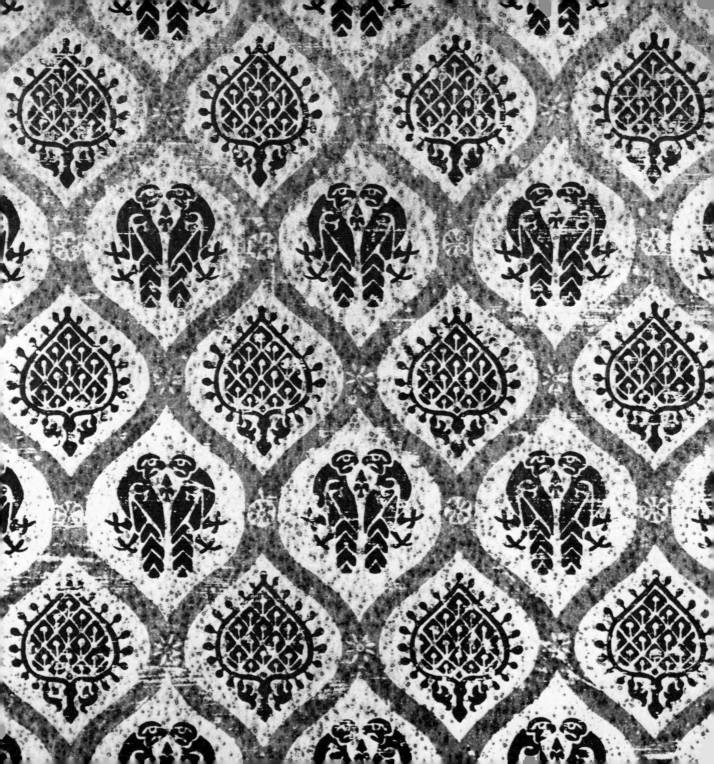

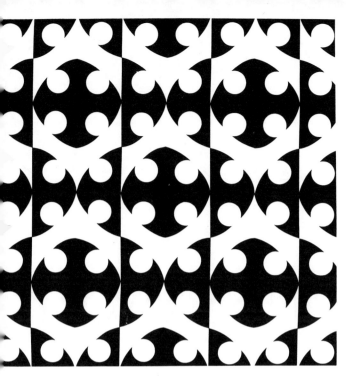

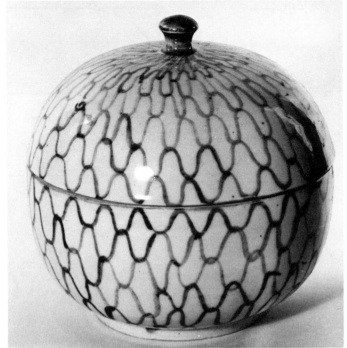

Above left: Cut-paper design by Norma Beale. Pattern is achieved by varying placement of a "quarter-round" unit. *Above right:* Round jar, porcelain, from Japan. Horizontal ogee net lines diminish at the top, enhancing the spherical form. Courtesy of the Henry Art Gallery, University of Washington. *Right:* Cut velvet based on a modified ogee form, Italy, 16th century. Courtesy of Costume and Textiles Study Collections, School of Home Economics, University of Washington.

FACING PAGE—"Regensburg," foil wallpaper designed by David Winfield Willson. Adapted from a 13th-century German damask. Courtesy of the manufacturer, Winfield Design Associates, Inc., San Francisco.

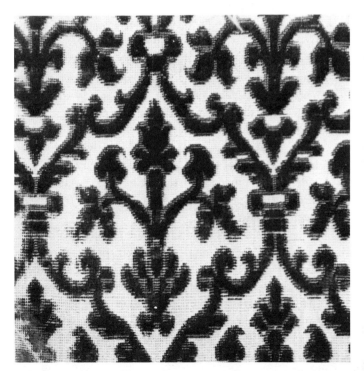

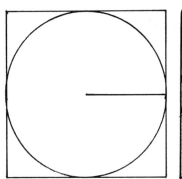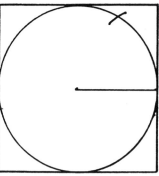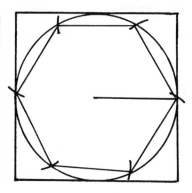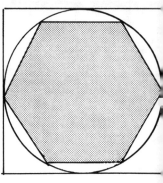

6·THE HEXAGON NETWORK

If the radius of a circle is consecutively marked off on the circumference of that circle, six equidistant points will result. A line connecting these six points yields a polygon with six sides and six angles—an equilateral, or regular, hexagon (see diagram above). The hexagon will repeat itself endlessly without producing any negative, or "leftover," spaces.

Regular hexagons can also be arrived at by rotating six equilateral triangles or three rhombuses on a common point. A myriad of irregular hexagonal variants can be derived from the arrangement of irregular triangles or lozenges (see overleaf).

Pentagons and octagons are forms that also make interesting compositional units but produce negative spaces when repeated. In most cases where these figures are used, it will be found, they are either overlapped or diapered on some other network (see pages 78 and 79).

Tortoise shells, honeycombs, and snowflakes and other crystalline structures are examples of hexagonal design in nature. The Japanese decorative arts—particularly textiles—frequently make use of the hexagon (see page 76), especially bold tortoise-shell patterns. Architecturally, the hexagon network is a useful device for joining spatial units (e.g., Frank Lloyd Wright's "Honeycomb House," now the Paul Hanna residence in Palo Alto, California).

Whether the hexagon is used structurally or decoratively, as a unit or in repetition, it is characterized by a feeling of stability and order. Only by rotating an asymmetrically decorated regular hexagon unit (as in block printing) is this impression likely to change.

FACING PAGE—Scored, folded, and cut paper project by a student of the author. Alternately advancing and receding horizontal lozenges appear in the center of each unit.

PAGES 72-73—Sketch by the author, demonstrating variations in hexagonal-unit and network formation.

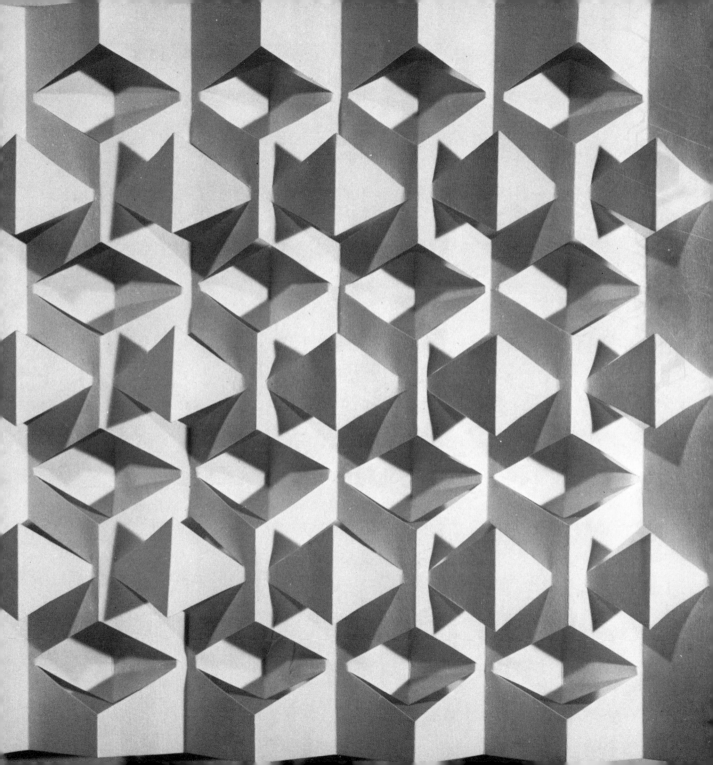

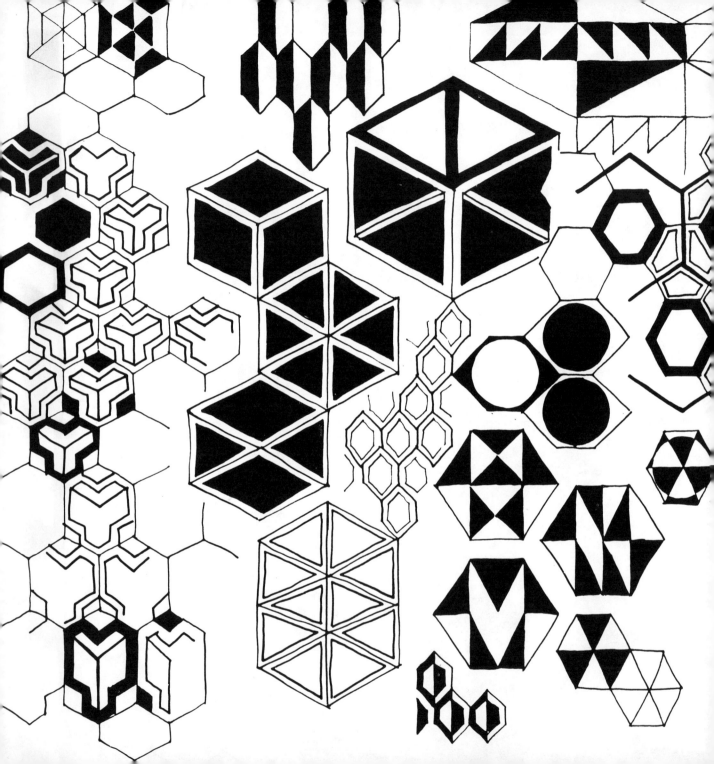

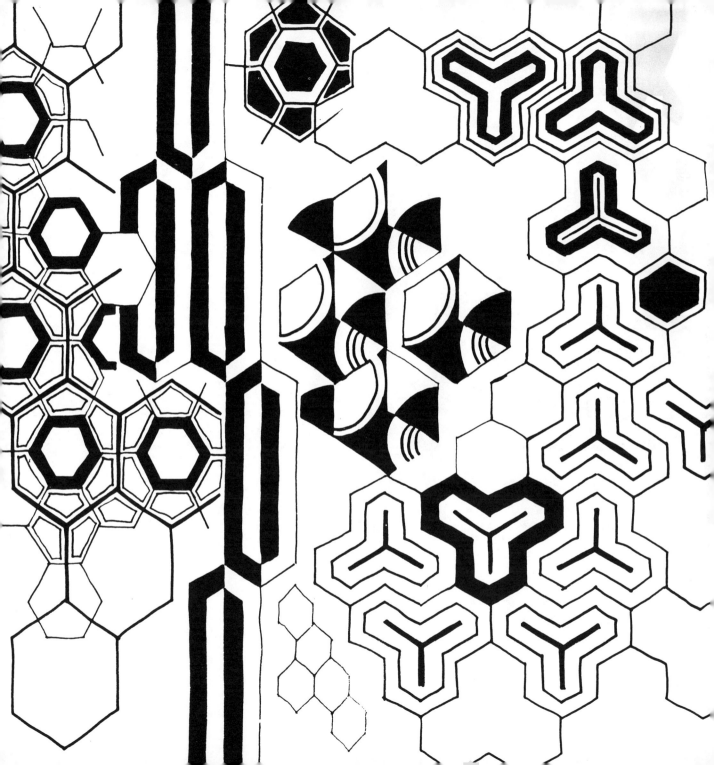

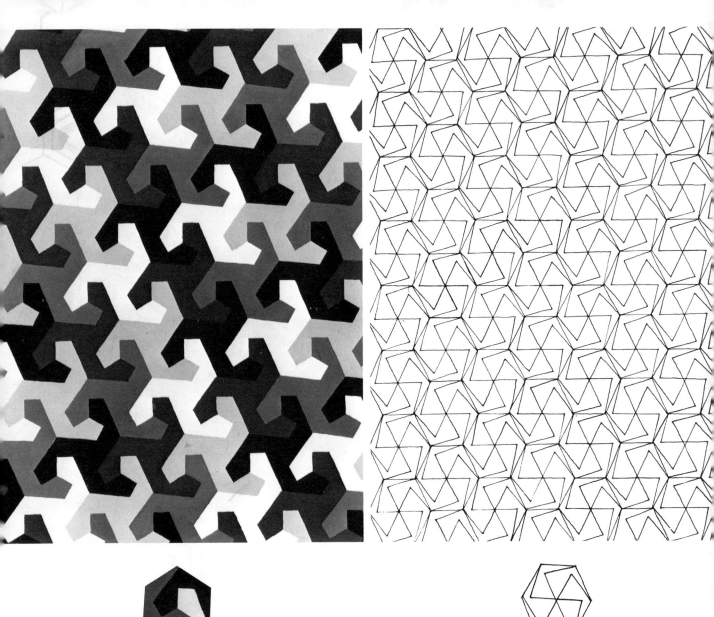

Four hexagon repeat compositions by
students of the author. The first and third
examples are gouache on paper; the second is an

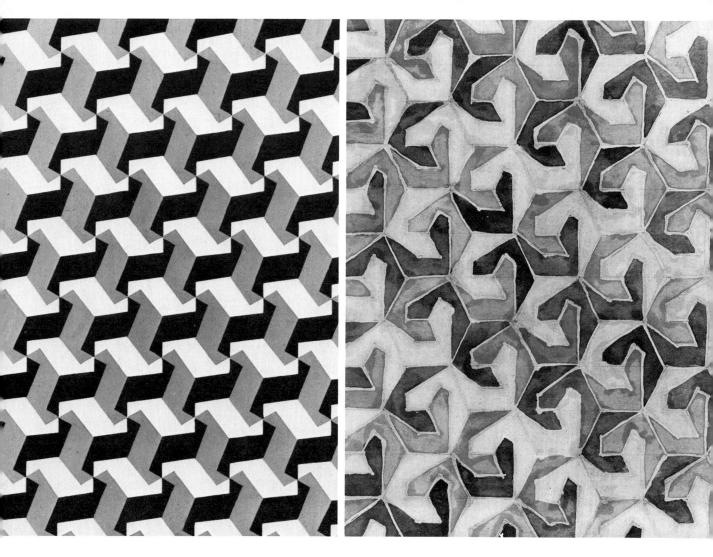

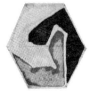

ink drawing; and the fourth is a paper
batik. Note that in the first and third designs
unit and network are nearly impossible to locate.

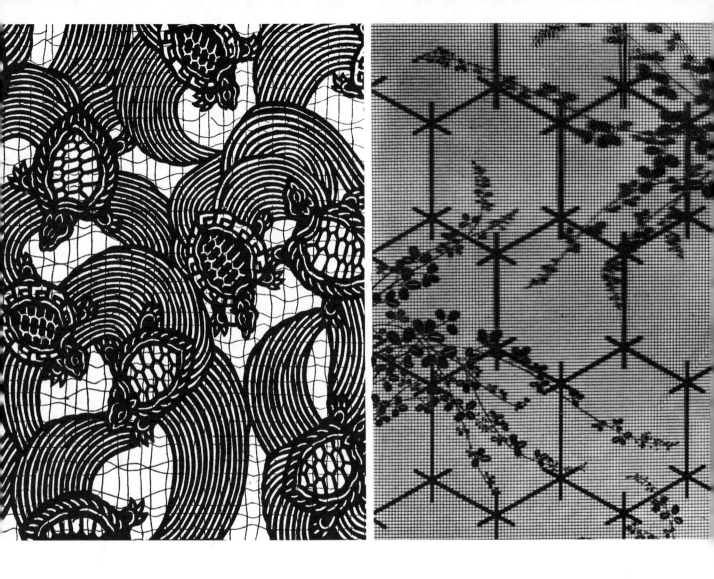

Above left: Japanese stencil design intended for textile production. *Above right:* Japanese paper stencil, Edo Period (18th-19th century). Approximately 14¼″ x 19″. Hexagonal frames contain a foliate design on a ground of squares. Courtesy of the Eugene Fuller Memorial Collection, Seattle Art Museum.

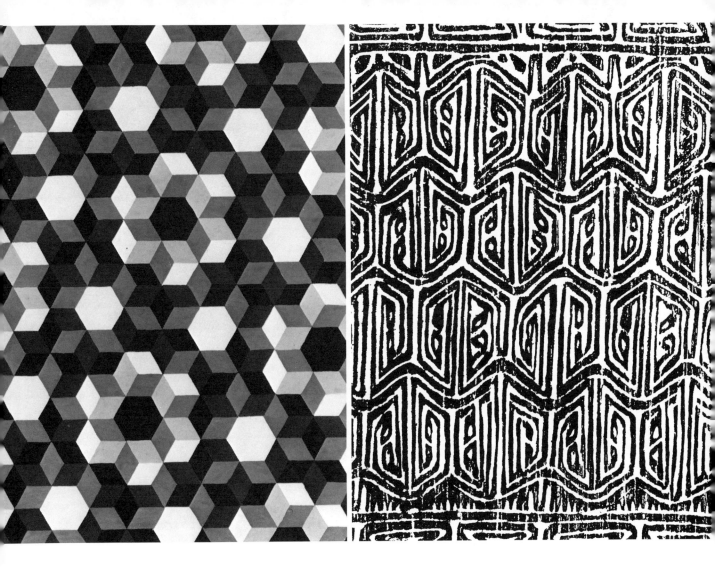

Above left: Design problem by a student of the author. *Above right:* Rubbing from a
New Guinea spear. Courtesy of the Field Museum of Natural History, Chicago.

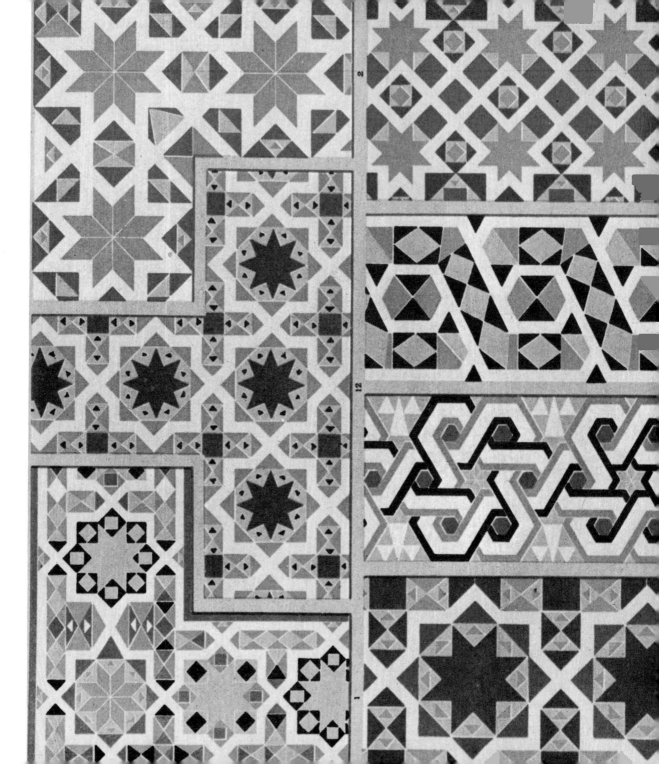

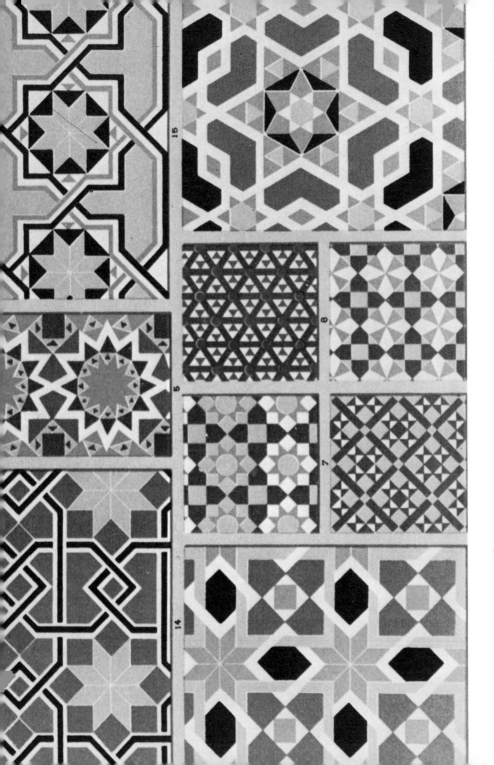

Mosaic designs from the Palatine Chapel and the Ziza Palace at Palermo and the Cathedral of Salerno, 12th century. Reprinted from *Polychrome Ornament* by Albert Racinet, London, 1877. Most of these motifs are based on the hexagon and show its close relationship to the diamond and triangle.

OVERLEAF—Collage of hexagons and snow-crystal forms by the author, taken from Clarence P. Hornung's *Handbook of Designs and Devices,* Dover Publications, Inc., N.Y.

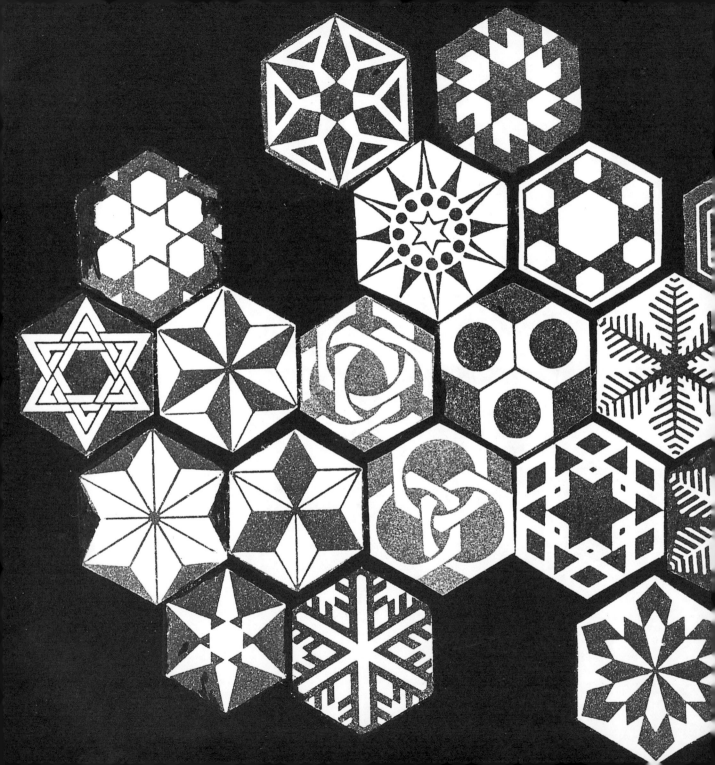

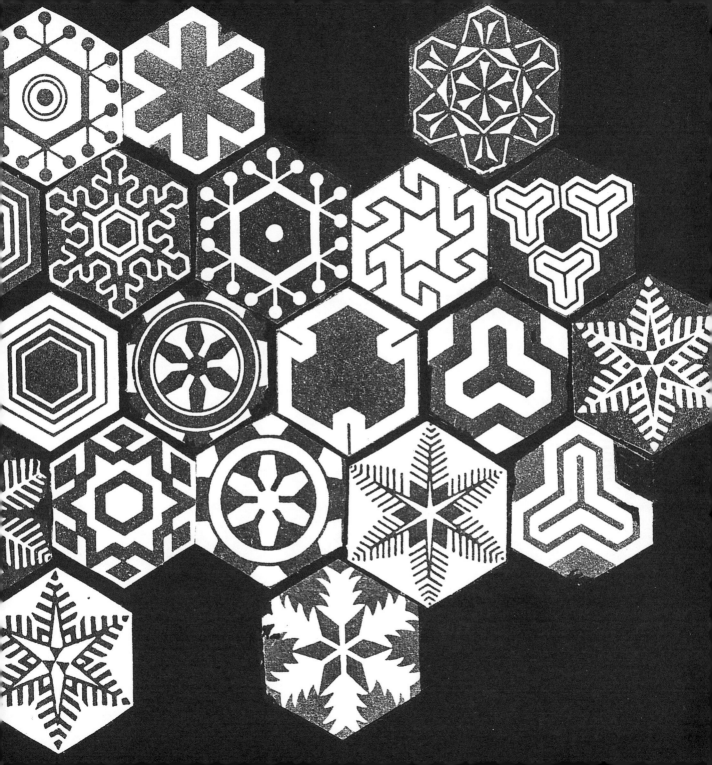

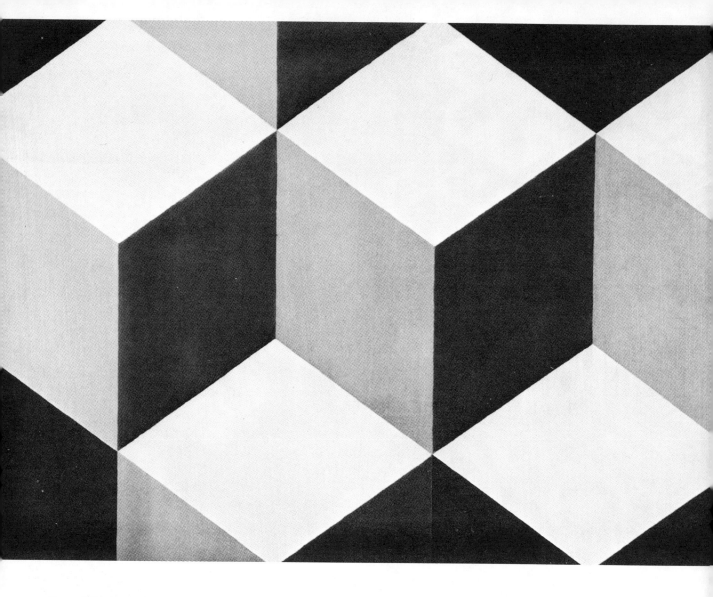

Above: "The Rise and Fall," by the
author. Acrylic on board, 24″ x 36″,
1968. The optical illusion of the shifting
cubes is created because some units are
"run off" the edges of the painting and
the cubes can be read as advancing or
receding in space.

FACING PAGE—"Winter's Occupation,"
by the author. Gouache on canvas, 18″ x
18″, 1968. Here again the hexagon is
broken into lozenges to create a cube
illusion. ("Winter's Occupation" was the
name given to many Early American
patchwork quilts; hence, the title of this
pattern which resembles a tattered quilt.)

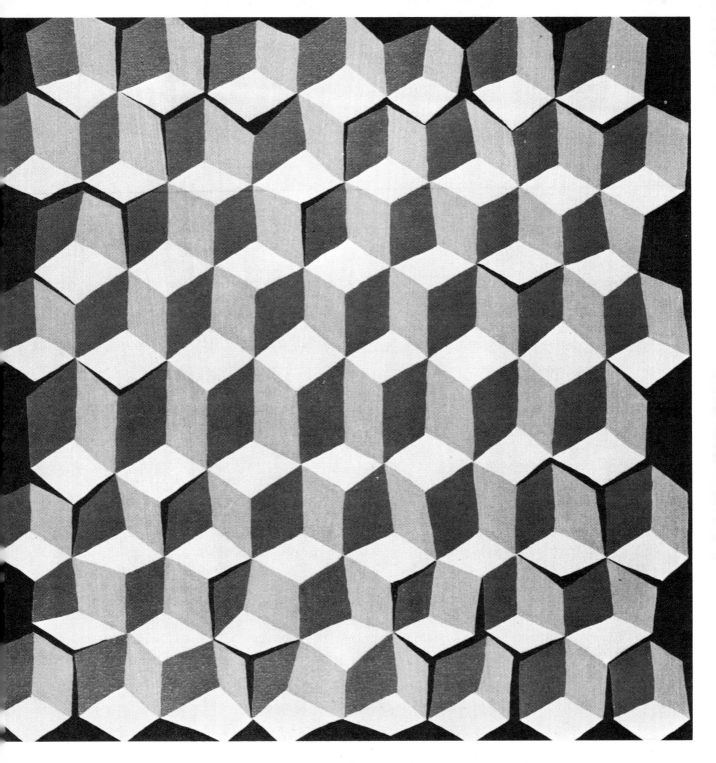

7 · THE CIRCLE

Any arrangement of circles tangent to each other will produce a pattern with negative spaces between the units (as may be seen on pages 86 and 90). For this reason, the circle cannot be made to produce a true interlocking network. The overlapping of circles, however, will produce a network of scales (see Chapter 8). Further, circles treated as units and arranged on other networks are so common that a chapter devoted to them is well warranted.

Ordinarily, circles are repeated on square diapers (pages 86 and 87) or half-drop diapers (page 90). The ever-present polka dot, for example, follows either of these schemes, deriving whatever uniqueness it may have from scale, spacing, texture, and color.

We are visually bombarded by so many common circular forms—buttons, balls, bottle caps, bowls, hubcaps, trademarks, and so on—that we tend to take the figure for granted, and it is only an exceptionally well-designed circle unit that arrests our attention. Partly in spite of its fam-

iliarity and partly because of it, the circle is a difficult shape to design for. Anyone can place a star or flower in the center of a circle and arrive at an acceptable unit, but to give it life, variety, movement, uniqueness, and repeatability is difficult indeed.

Because there is no true circle network, "unit quality" rather than "yardage quality" has been stressed in this chapter. The examples that follow have been selected from the standpoint of providing visual resources, and they demonstrate varied and skillful means of handling the circular format.

FACING PAGE—"Blaze IV," by Bridget Riley. Emulsion on board, 37¼″ x 37¼″, 1963. Collection of Mrs. Louise Riley. Courtesy of the Richard Feigen Gallery, New York and Chicago.

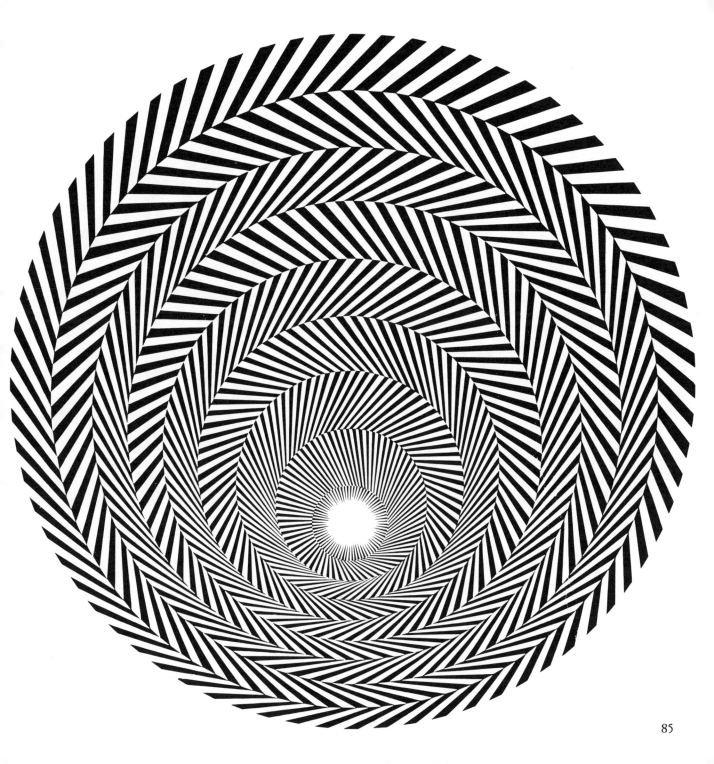

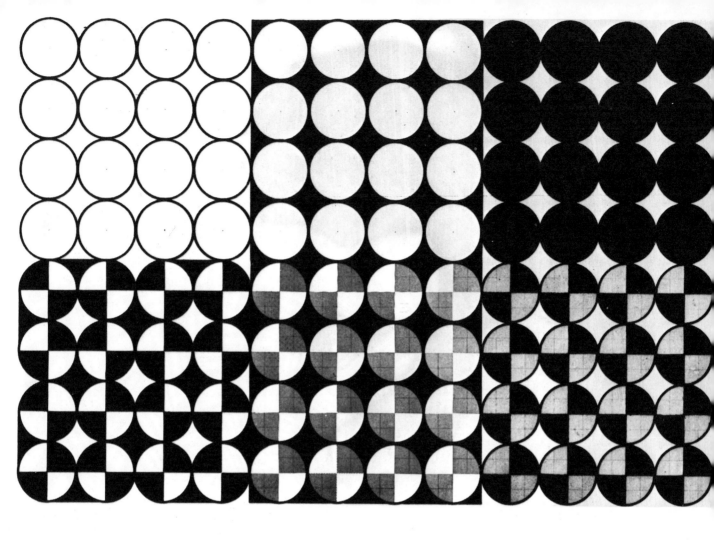

Circles (above) and rings (facing page) have been neatly fitted to the square grid. Variety in impact and surface movement was achieved by the use of quartering, value distribution, and counterchange. Diagrams by Norma Beale.

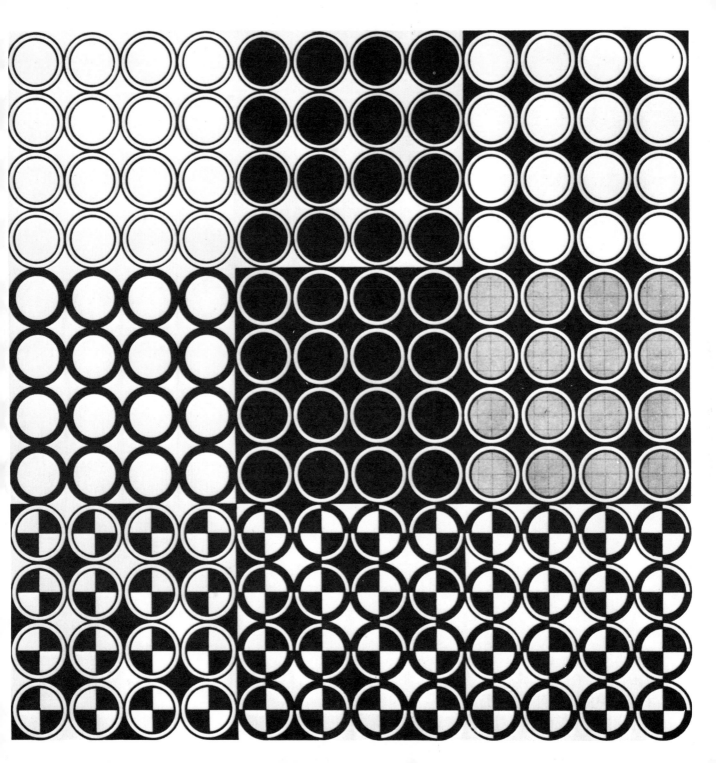

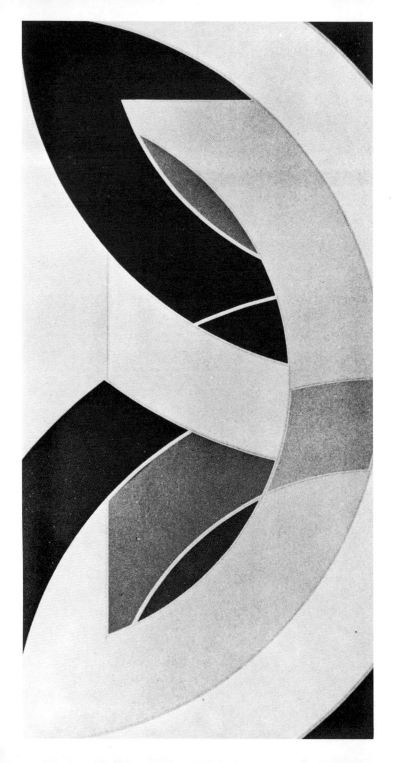

The remarkable, inventive series of large paintings on these two pages is based on sections of the circle. Although none of these paintings by Frank Stella could be called formal pattern, the artist has employed such pattern devices as recurring intervals, element rotation, overlapping, and symmetry.

Left: "Saskatoon II," 96″ x 48″, 1968.

FACING PAGE—*Top left:* "Flin Flon I," 96″ x 96″, 1967. *Top right:* "Wakesu I," 96″ x 96″, 1968. *Bottom left:* "Wakesu II," 98″ x 98″, 1968. *Bottom right:* "Flin Flon II," 96″ x 96″, 1968. All are acrylic on canvas. Courtesy of the David Mirvish Gallery, Toronto.

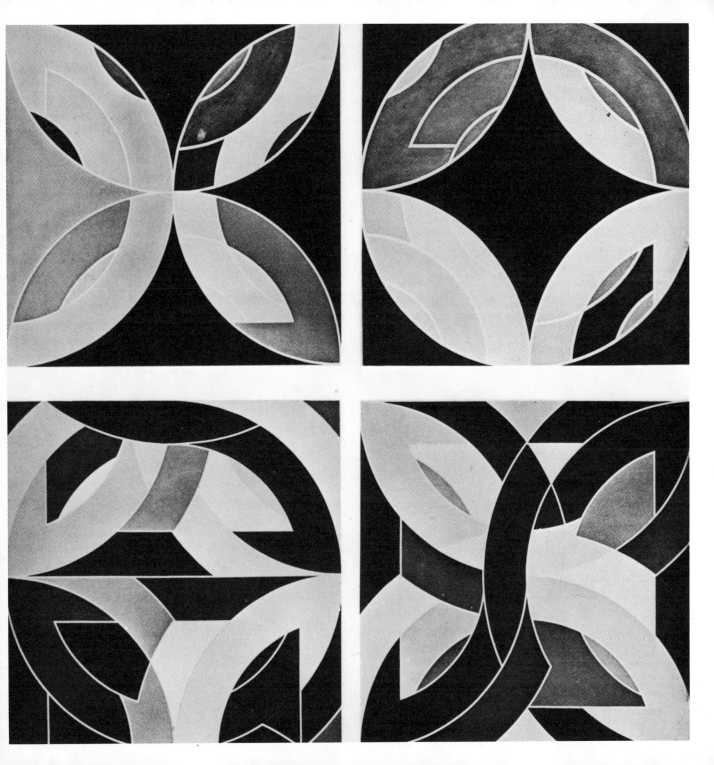

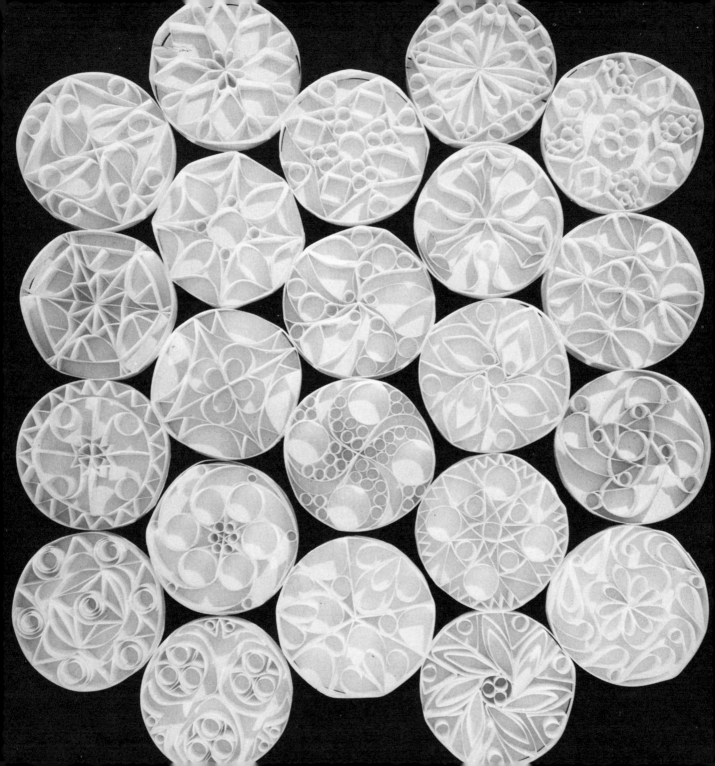

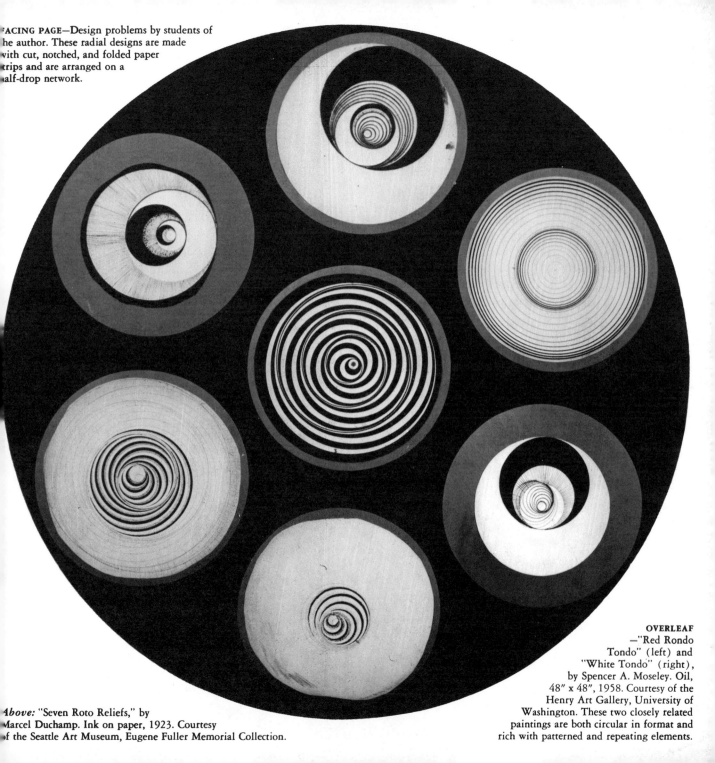

FACING PAGE—Design problems by students of the author. These radial designs are made with cut, notched, and folded paper strips and are arranged on a half-drop network.

Above: "Seven Roto Reliefs," by Marcel Duchamp. Ink on paper, 1923. Courtesy of the Seattle Art Museum, Eugene Fuller Memorial Collection.

OVERLEAF —"Red Rondo Tondo" (left) and "White Tondo" (right), by Spencer A. Moseley. Oil, 48″ x 48″, 1958. Courtesy of the Henry Art Gallery, University of Washington. These two closely related paintings are both circular in format and rich with patterned and repeating elements.

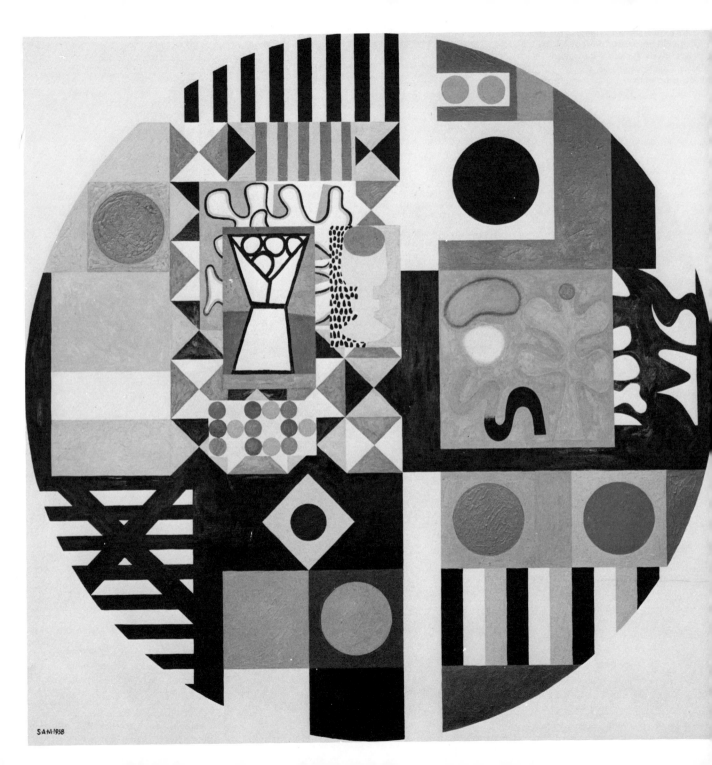

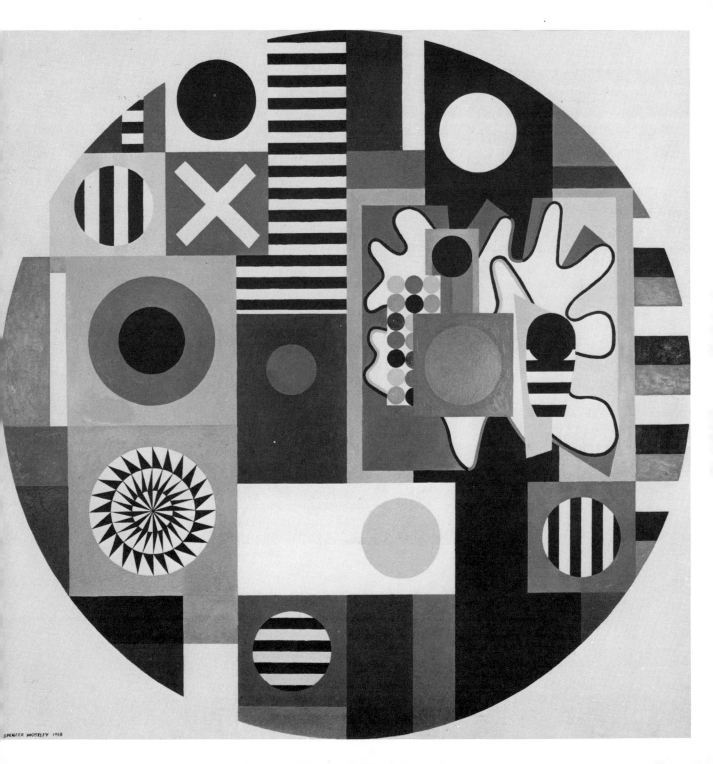

SPENCER MOSELEY 1958

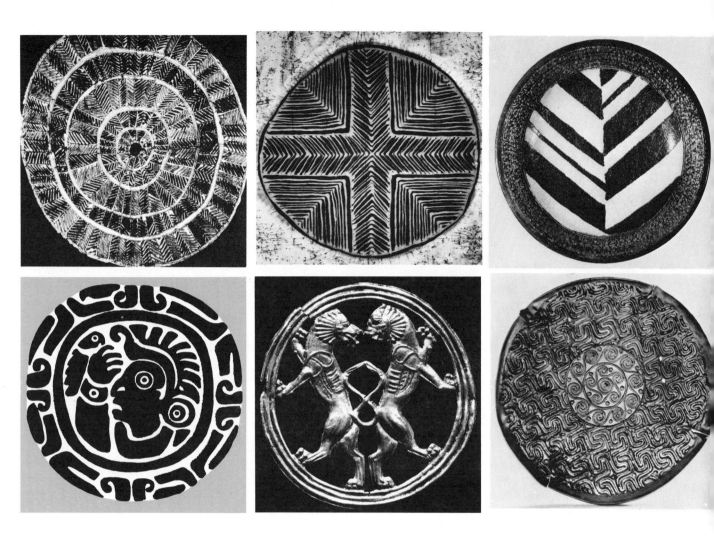

Top left: Batik panel by Jennifer Lew. *Top center:* Detail of batik banner by the author. *Top right:* Ceramic *raku* bowl by Mar Hudson. *Bottom left:* Drawing after a pre-Columbian clay stamp from Mexico by Jorge Enciso. *Bottom center:* Bracteate showing rampant lions, Iran, Achaemenid period (5th century B.C.). Gold repoussé, 1⅝" diameter. Courtesy of the Seattle Art Museum, Eugene Fuller Memorial Collection. *Bottom right:* Disk, mortuary offering, Mycenaean, 1500 B.C. Gold repoussé, 6⅝". Courtesy of the Seattle Art Museum, gift of Mr. and Mrs. William Garrard Reed.

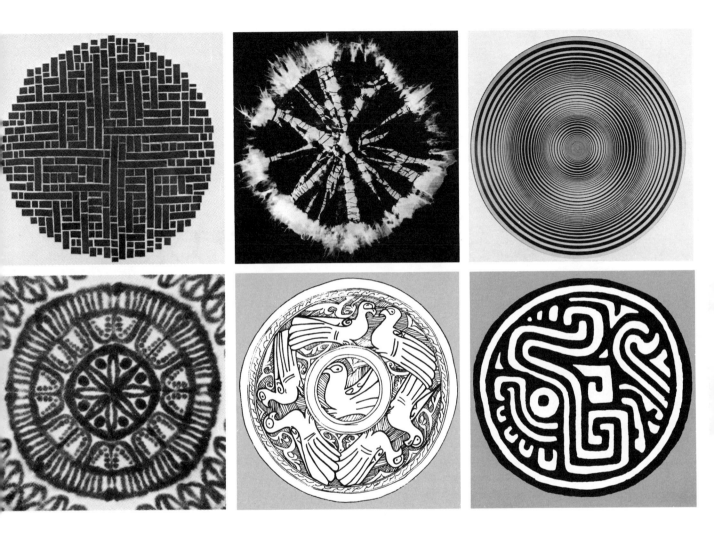

Top left: "Black Ball," by the author. Ink and charcoal drawing, 18″ diameter.
Top center: Detail of tied and bleached wall hanging by the author. *Top right:*
"Elliptical Series C," by Francis Celentano. Color serigraph, 23¾″ diameter. Courtesy
of the Henry Art Gallery, University of Washington. *Bottom left:* Fold-dyed paper
design by Jennifer Lew. *Bottom center:* Drawing after 8th-century Iranian sgraffito bowl
by Norma Beale. Courtesy of the Seattle Art Museum, Eugene Fuller Memorial Collection.
Bottom right: Drawing after a pre-Columbian clay stamp from Mexico by Jorge Enciso.

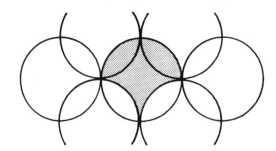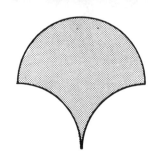

8. THE SCALE NETWORK

Scale patterns are usually derived from geometry, overlapping and tangent circles being the foundations for the network (see diagram above). Many scale patterns also suggest zoological inspiration—a similarity to the scales of a fish or the neck feathers of a bird is quite common. In addition, because the scale closely resembles an open fan or floral profile, many examples use linear radiation and suggest botanical cross-sections.

The conventional scale network, with its alternating scallop effect, is somewhat restricting. Depending on the technique involved, the designer can provide variety by changing the direction of the units or by distorting their shape.

If the vertical and horizontal dimensions of the scale units are exactly equal, changes may also be made in the way the units join (see pages 102-103). Undulating lines and shapes, diagonals, and modified circles emerge when the unit is rotated or radiated. Perhaps the most interesting and useful variation is the ogee that results from paired scales (two facing in and two facing out). Need-

less to say, this variation is best repeated on the ogee network.

When the scale unit is repeated with the point downward, the feeling of the design is generally one of ascent, and vice versa (look at the illustration on the facing page upside down). An ogee placement tends to give a more serpentine movement and a less specific directional tension, as does an undulating placement of scales (see, for example, the illustrations on pages 102 and 103, below left).

Oriental designers have made remarkably inventive use of the scale motif for centuries. Early American hooked rugs, African tribal art, and contemporary textiles also attest to the diverse character of the scale repeat.

FACING PAGE—Block-printed textile by the author. Oil-base ink on sheer cotton. Approximately 36″ x 36″.

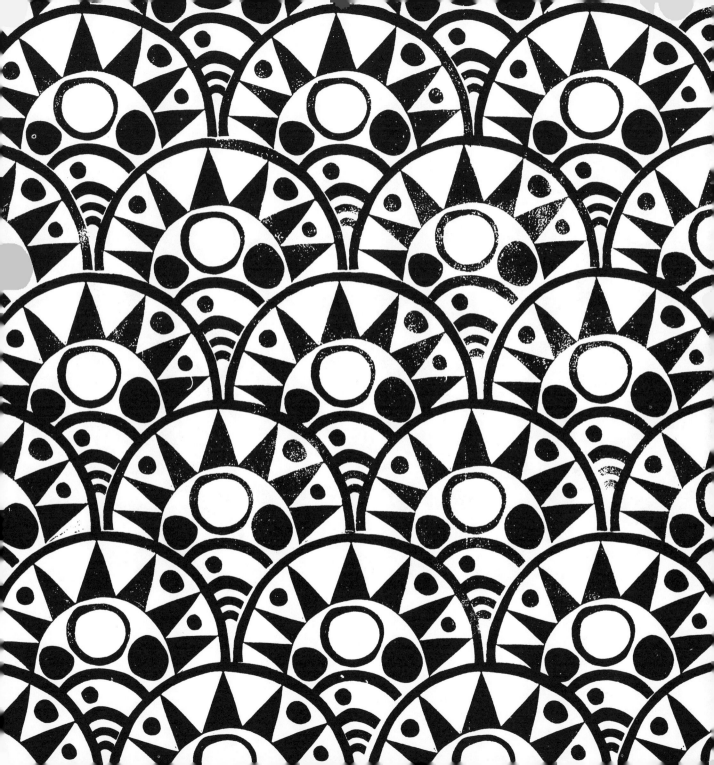

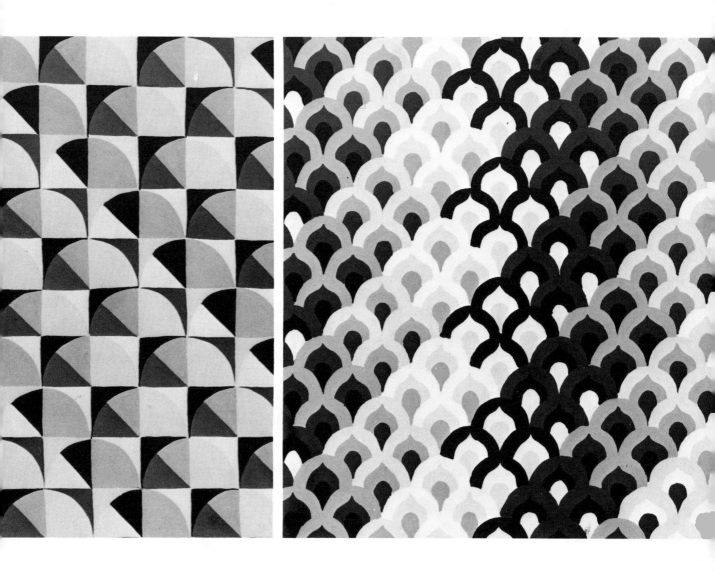

Five scale-unit design problems by students of the author.

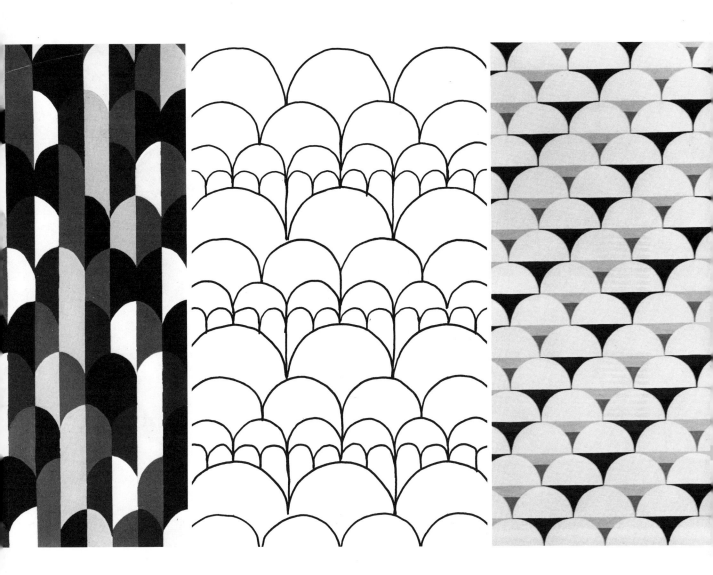

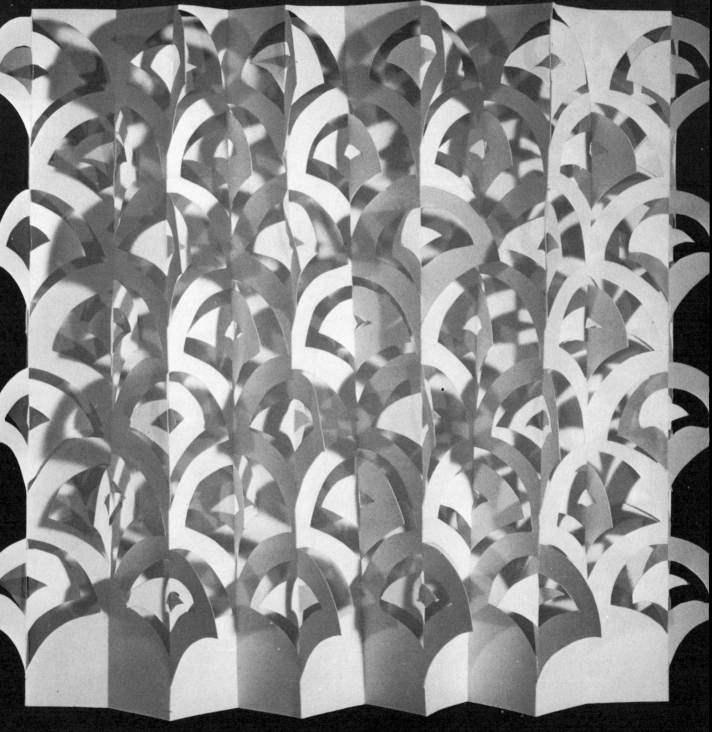

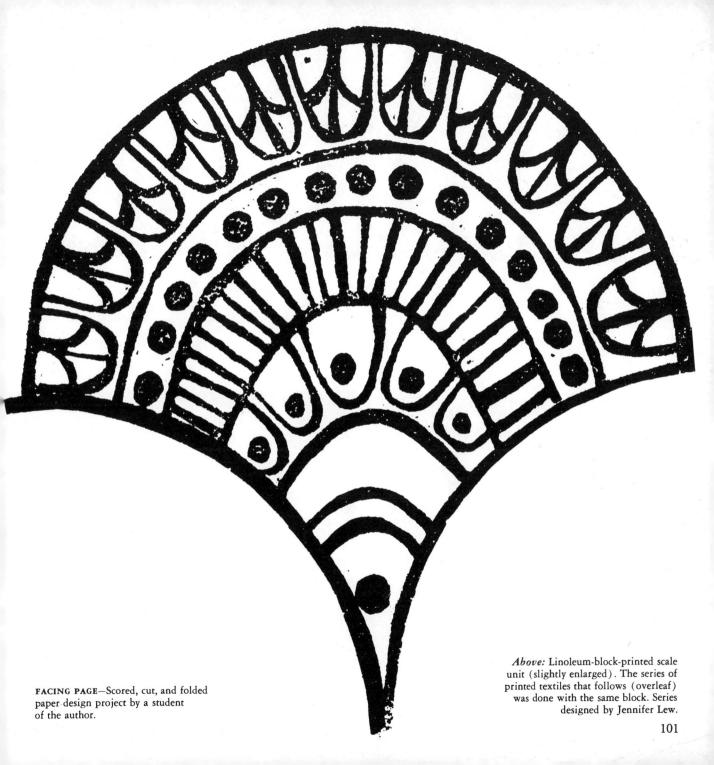

Above: Linoleum-block-printed scale unit (slightly enlarged). The series of printed textiles that follows (overleaf) was done with the same block. Series designed by Jennifer Lew.

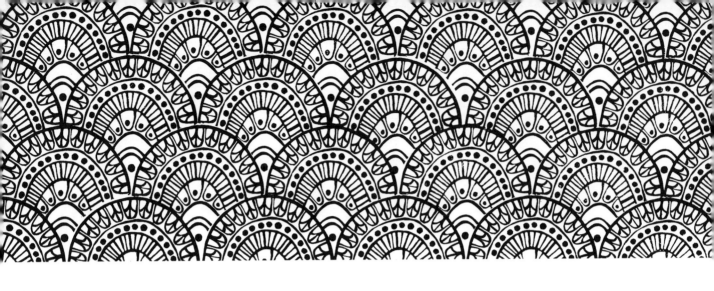

Above: Scale units in conventional network placement. *Below left:* Units printed in alternating diagonal rows produce undulating movement. *Below right:* Radial design. Scale units always produce some negative spaces when radiated.

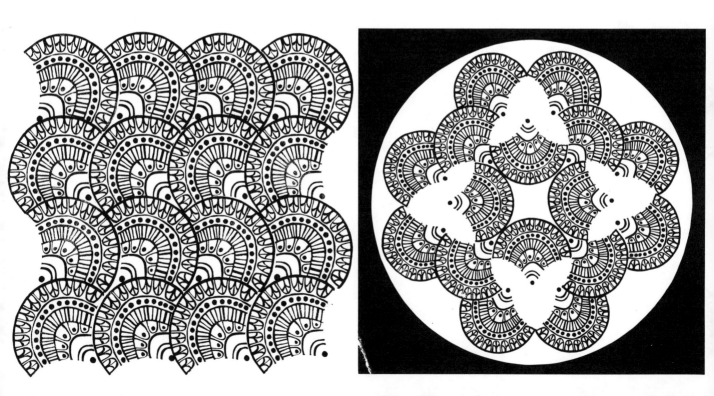

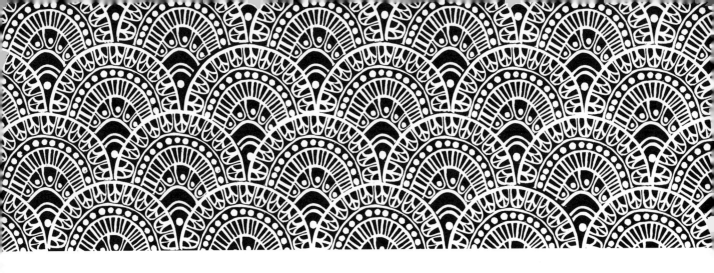

Above: Photographic reversal of the design on the facing page.
Below left: Paired scale units forming an ogee network.
Below right: Uniform diagonal placement of the same unit. Note similarity to conventional placement (facing page).

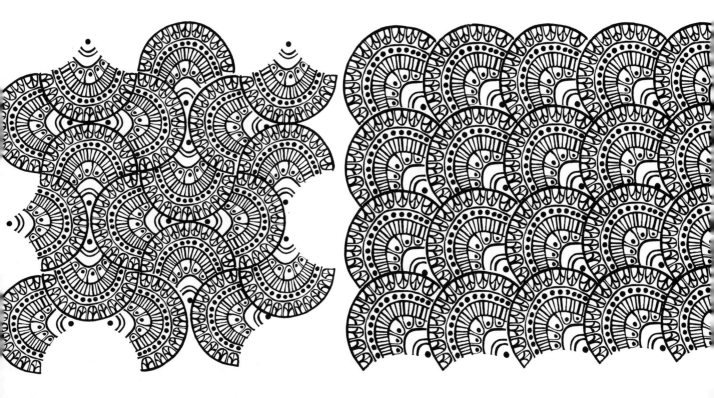

Batik apparel yardage by Karen Okubu. The mosaic-like effect is the natural result of applying melted wax in short strokes with a flat brush.

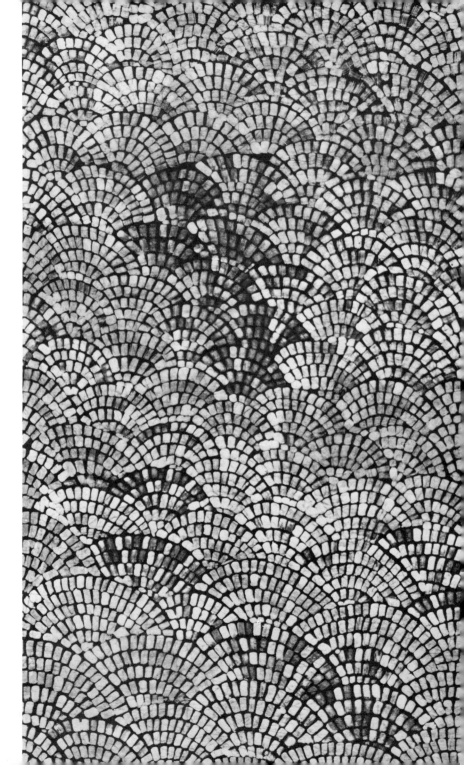

Japanese stencil. Courtesy of Costume
and Textile Study Collections, School of
Home Economics, University of
Washington.

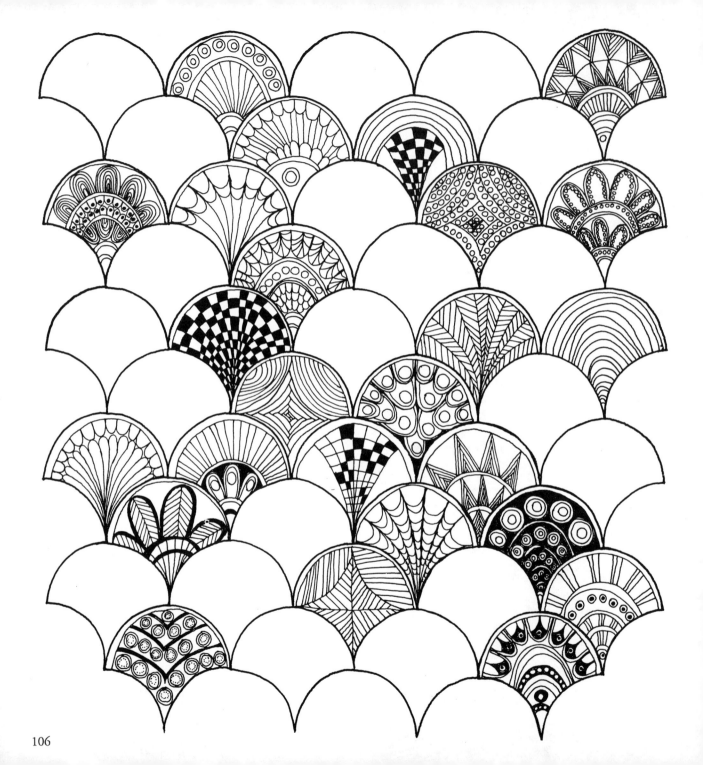

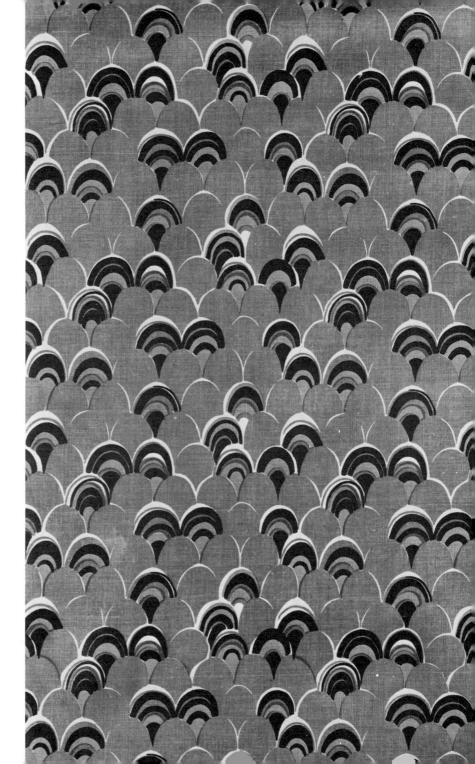

FACING PAGE—Page from a designer's sketchbook. Courtesy of Jennifer Lew.

Right: "Dayton/Tralle-Stone," printed textile. Courtesy of the manufacturer, David and Dash, Miami.

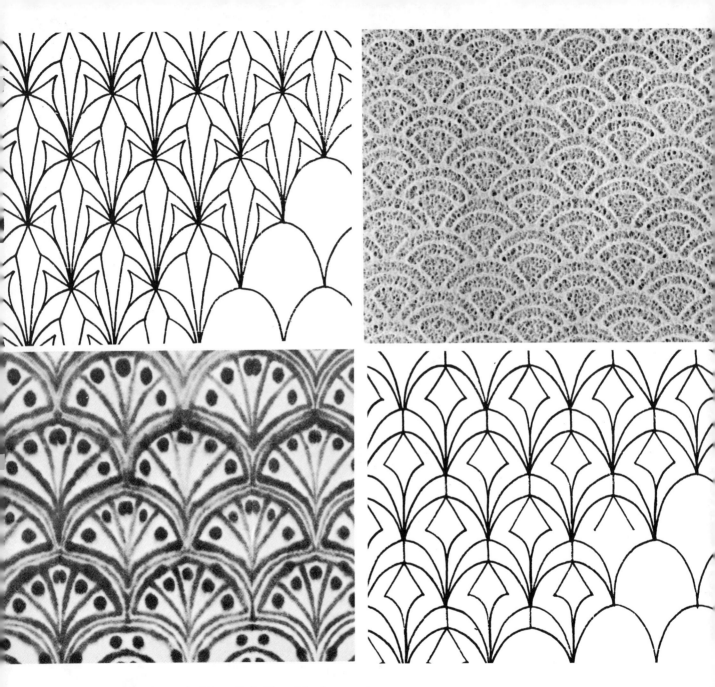

Top left: Scale repeat diagram by Norma Beale. ***Top right:*** Japanese rice paper.
Bottom left: Fold-dyed decorative paper by Jennifer Lew. ***Bottom right:*** Scale repeat
diagram by Norma Beale.

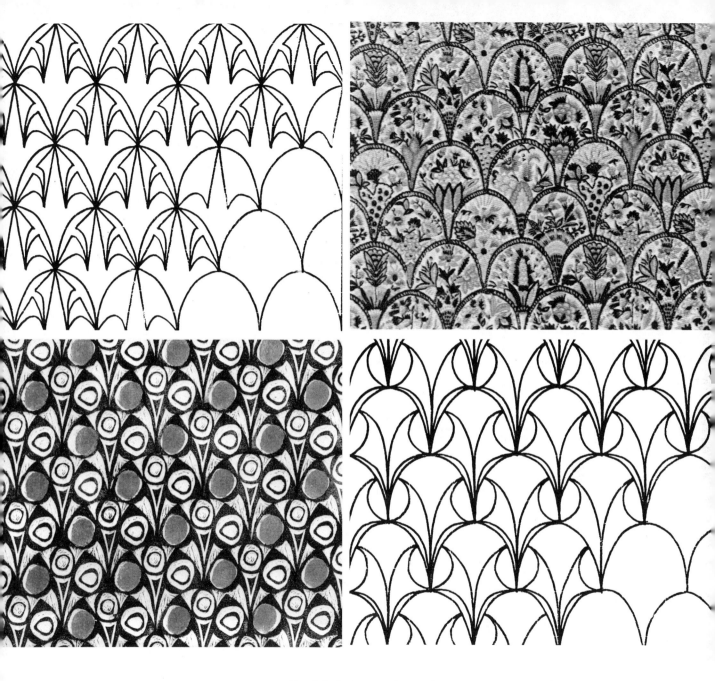

Top left: Scale repeat diagram by Norma Beale. *Top right:* Printed textile (pattern #33917). Courtesy of the manufacturer, S. M. Hexter Company. *Bottom left:* Block-printed fabric by a student of the author. *Bottom right:* Scale repeat diagram by Norma Beale.

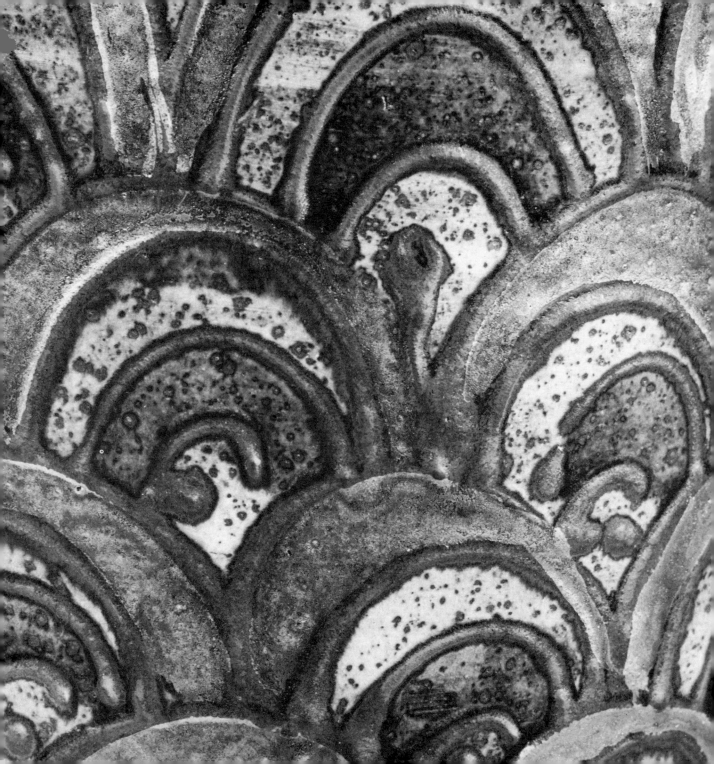

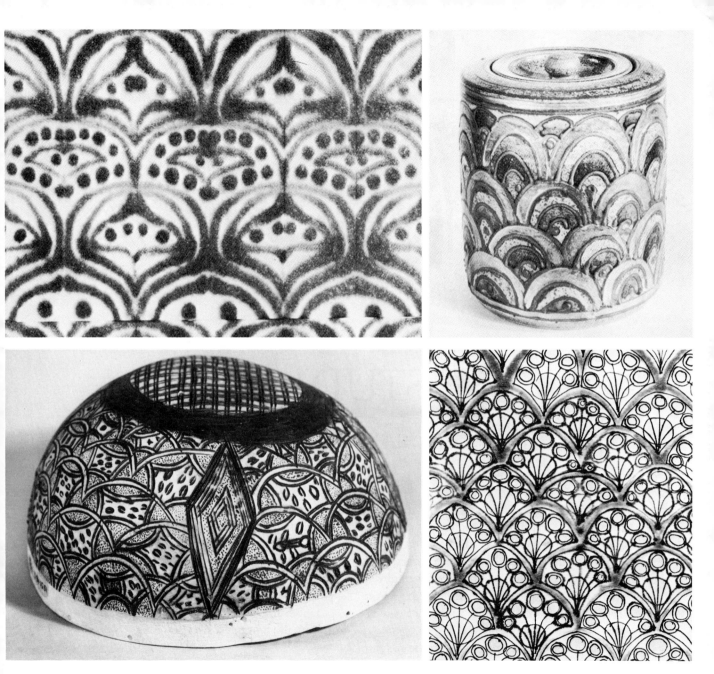

FACING PAGE—Enlarged detail
of covered jar (shown above)
by William Creitz.

Top left: Fold-dyed decorative paper by Jennifer Lew. *Top right:* Covered jar by William Creitz.
Stoneware, purchase award, collection of the Henry Art Gallery, University of Washington.
Bottom left: Scorched and engraved calabash, Hausa tribe, Bauchi town, Northern Nigeria.
Courtesy of The British Museum. *Bottom right:* Fold-dyed decorative paper by the author.

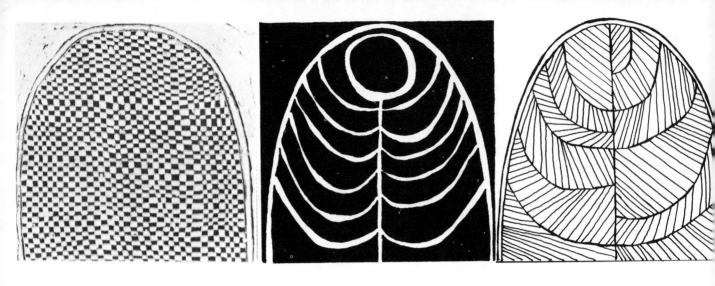

9. A CASE STUDY

A designer-craftsman is very fortunate when, by whatever means, he arrives at a motif that is versatile, challenging, personally satisfying, and suited to the craft medium in which he works. At this point he usually develops a series of related patterns that intensively explore, dissect, vary, and embellish that motif. The case study, or biography of a shape, on the following pages is included here to give the reader a brief glimpse of the designer's means of extending his visual range.

The shape or motif of this study can be roughly described as a Romanesque arch form. Because the arch fits no standard network, the designer was not only at liberty to improvise but indeed forced to do so.

Batik, a resist textile technique involving the suc-cessive application of melted wax and transparent dye, is the craft medium. (Books on the batik process will be found in the Bibliography.)

Almost all of the material that makes up this concluding chapter is the work of a talented young designer, Jennifer Lew. Although a few of the patterns shown here were executed for this book, most of the examples were produced for their own sake, with the sole object of exploring the range of a selected motif.

FACING PAGE—Detail of a batik wall hanging. (See page 123 for entire piece.)

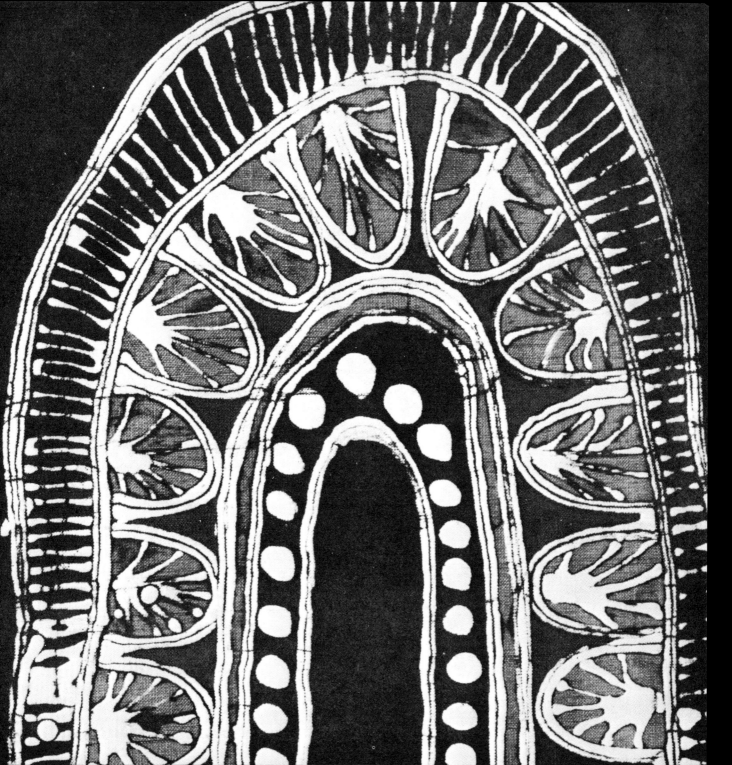

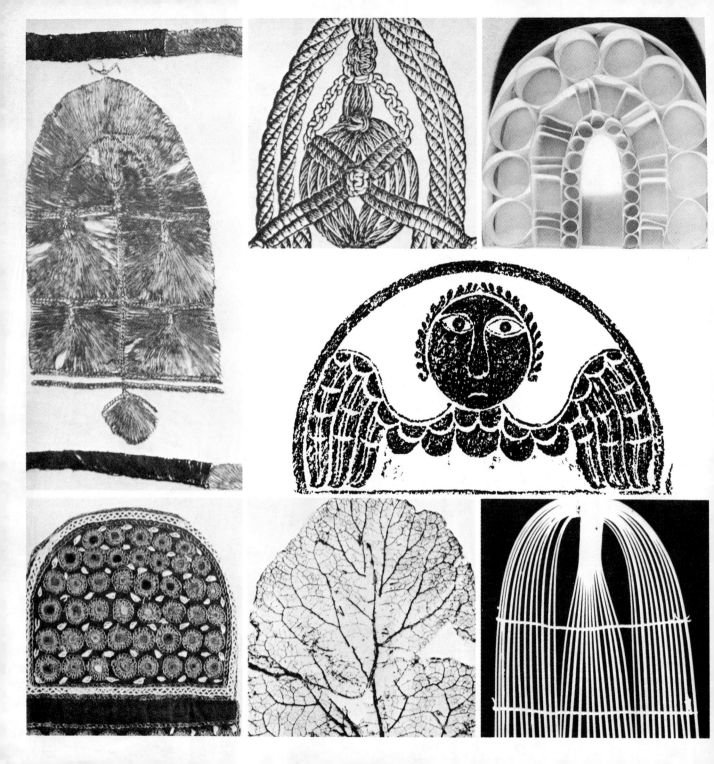

The photo-composite on these two pages shows diverse ways the rounded arch form can be used. (All textiles are from the Elizabeth Palmer Bayley Textiles of India, Costume and Textiles Study Collections, School of Home Economics, University of Washington.)

FACING PAGE—

FIRST COLUMN—*Top:* Embroidered veil, Punjab, India, late 19th century. *Bottom:* Embroidered bag, Bombay, India.

SECOND COLUMN—*Top:* Diagram from *Sylvia's Book of Macramé Lace*, ca. 1885. Courtesy of Virginia I. Harvey. *Center* (and third column, center): Early New England gravestone rubbing. *Bottom:* Wall plaque of skeletonized leaf impression. Courtesy of Keegs, Seattle.

THIRD COLUMN—*Top:* Paper ornament by Jennifer Lew. *Bottom:* Japanese fly swatter, 20th century.

FIRST COLUMN—*Top:* Rubbing from New Guinea paddle. Courtesy of the Field Museum of Natural History, Chicago. *Bottom:* Bronze bell hanging by the author.

SECOND COLUMN—*Top:* Mexican birdcage. *Center:* Pre-Columbian spindle whorls, from the collection of Ramona Solberg, Seattle. *Bottom:* Detail of embroidered skirt, Rajasthan, India.

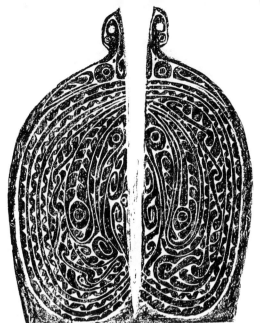

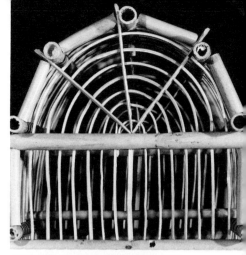

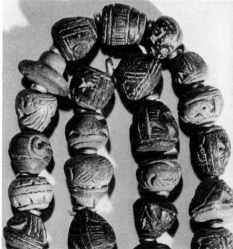

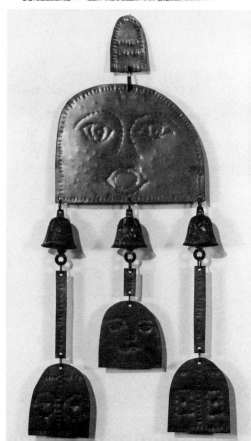

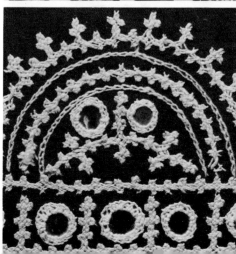

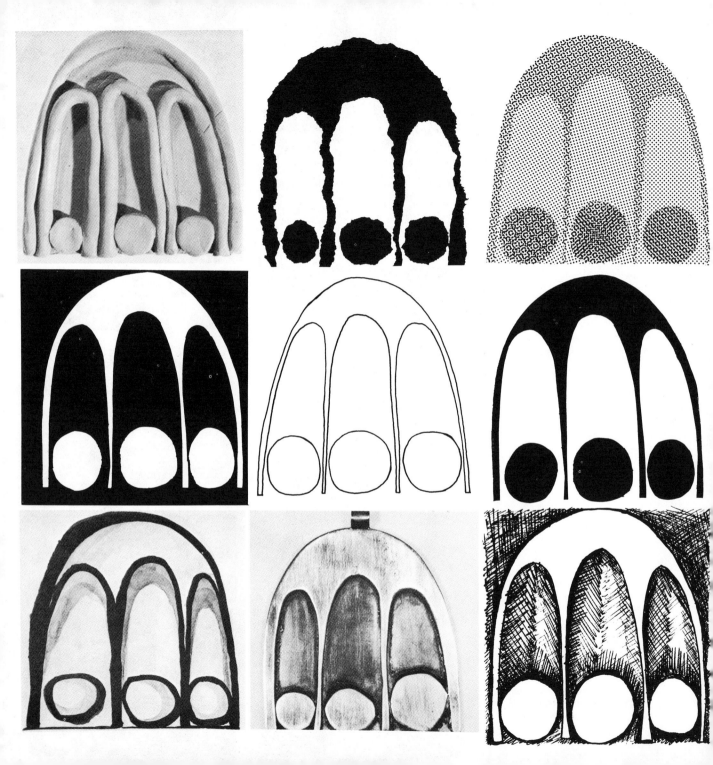

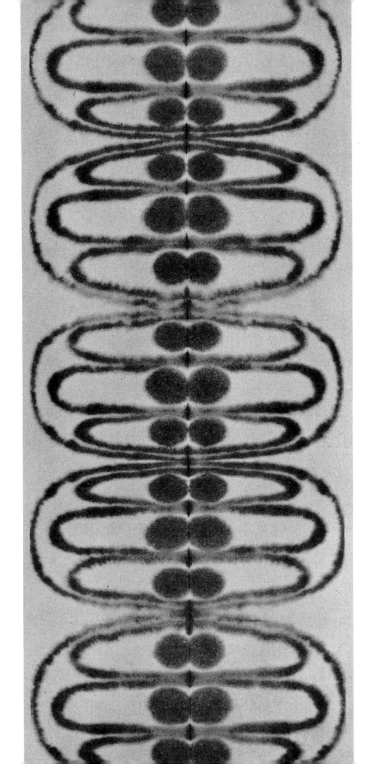

FACING PAGE—A media study showing variations on the same basic design (continues at right and overleaf).

FIRST ROW—*Left:* Clay coils. *Center:* Torn paper. *Right:* Shading film collage.

SECOND ROW—*Left:* Cut paper, white figure on black ground. *Center:* Ink drawing. *Right:* Cut paper, black figure on white ground.

THIRD ROW—*Left:* Ink wash. *Center:* Pendant, silver on brass, fabricated by Ron Ho. *Right:* Cross-hatched ink drawing.

Right: Fold-dyed paper. Silk span (model airplane) paper was folded, moistened, and painted with liquid food coloring.

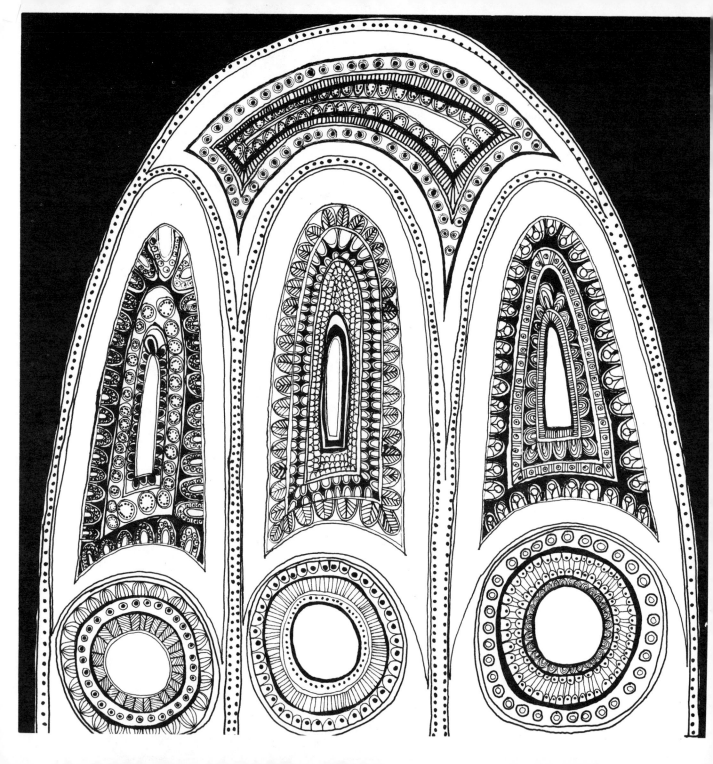

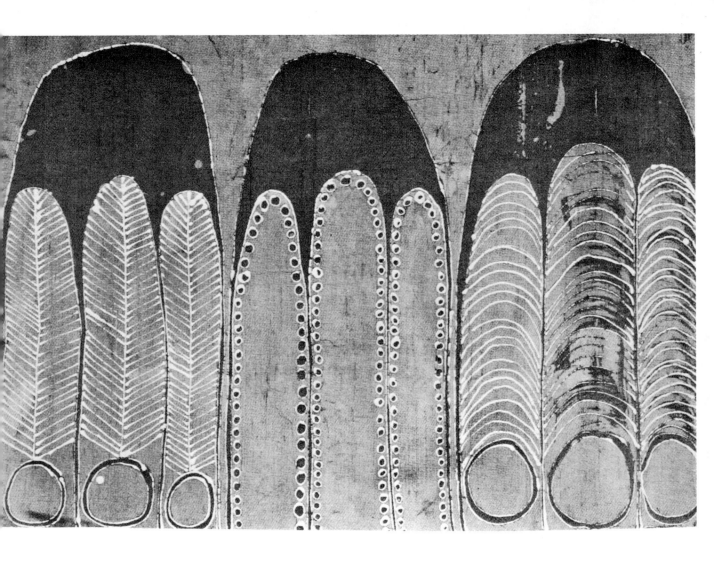

The same basic shape used on pages 116-117 has been treated with considerably more decorative detail in the designs on these two pages.

FACING PAGE—Opulent pen-and-ink drawing on white paper (actual size).

Above: Small batik banner, silk shantung, in blue-gray, plum, and off-white.

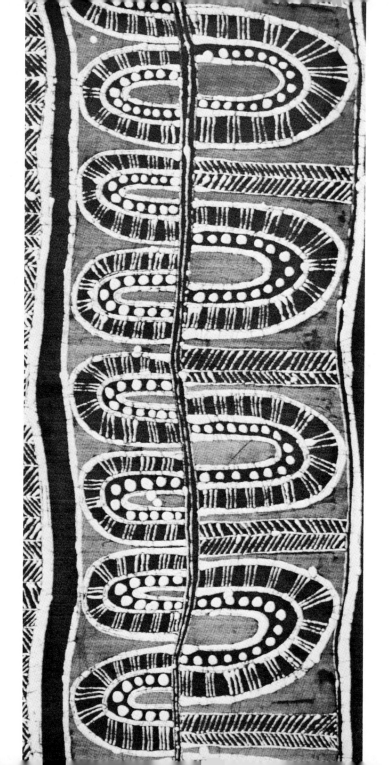

Detail of a batik wall hanging, in browns, oranges, and cranberry red. 39" high. Collection of Mar Hudson, Seattle.

FACING PAGE AND PAGE 122—Pages from the designer's sketchbook.

PAGE 123—Batik triptych, silk shantung, based on the drawing on page 122. Approximately 40" high. Center panel from the collection of Marvin Sharpe, Seattle.

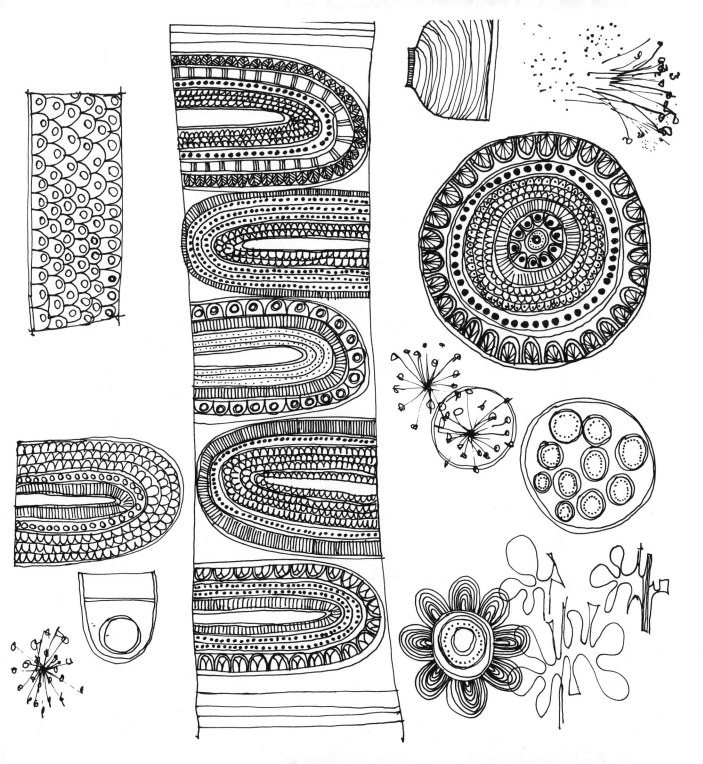

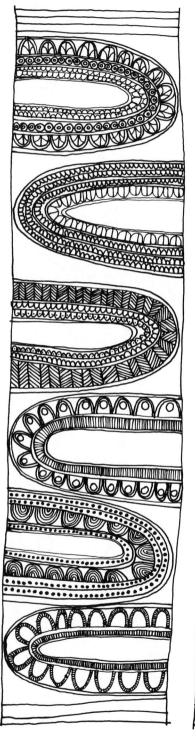
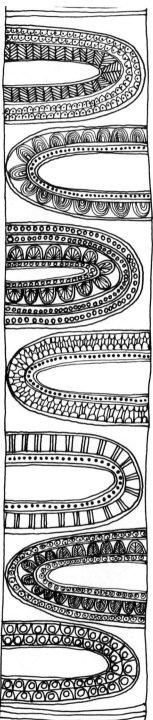
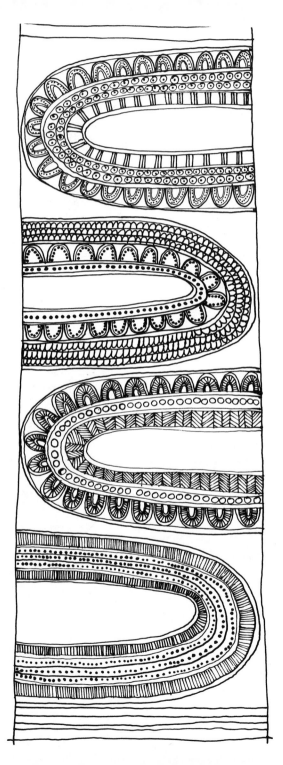

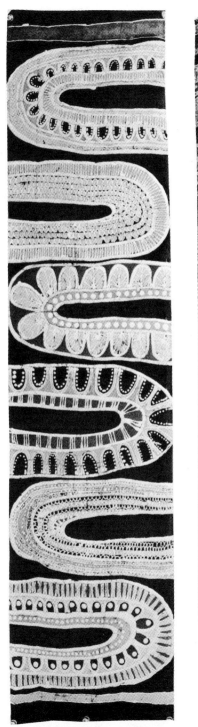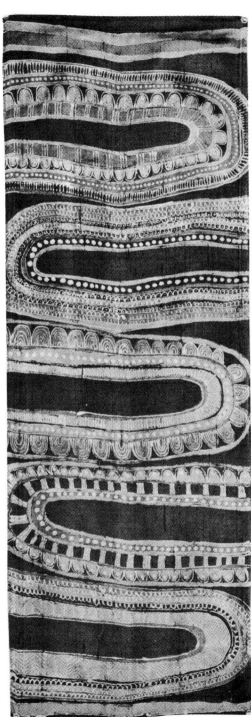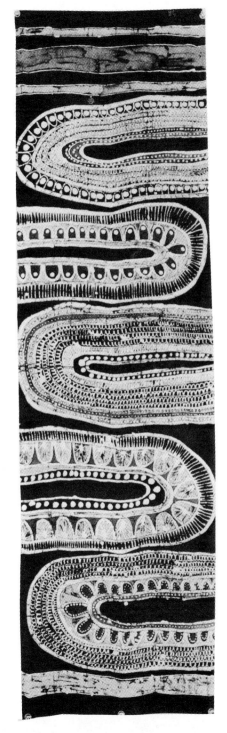

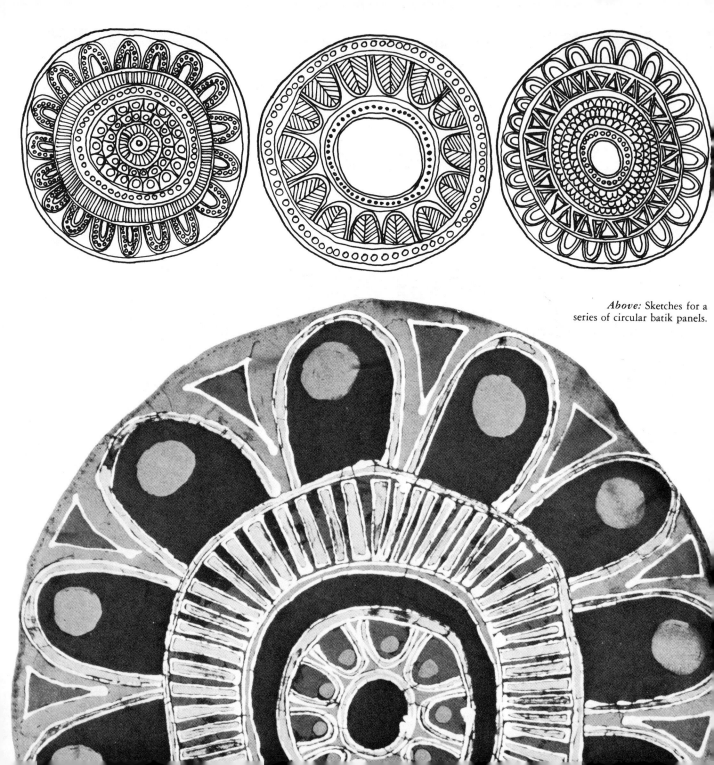

Above: Sketches for a series of circular batik panels.

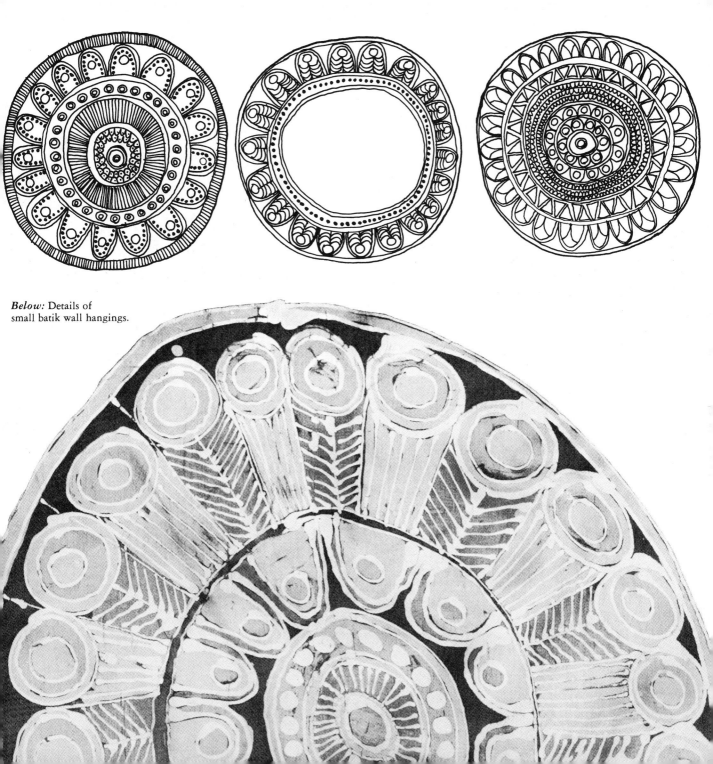

Below: Details of
small batik wall hangings.

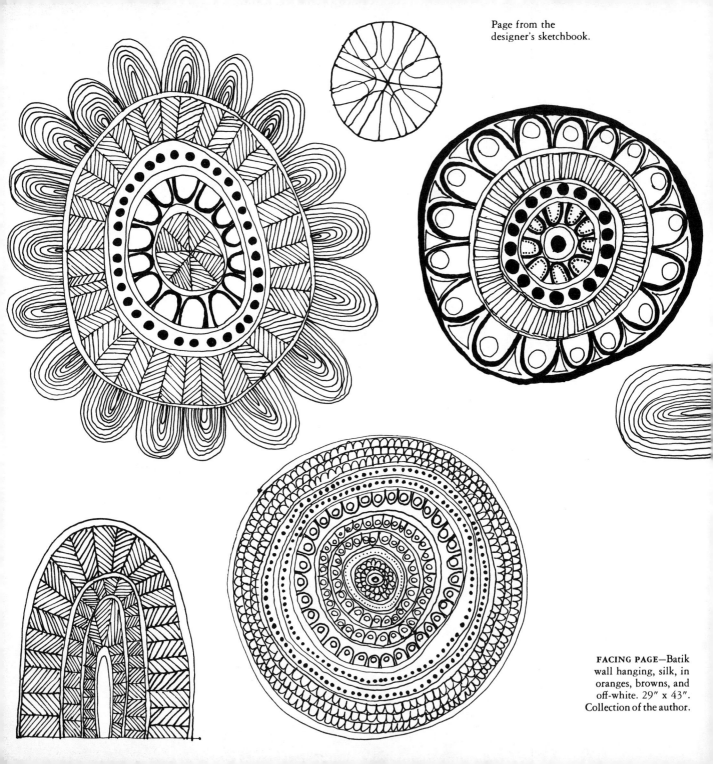

FACING PAGE—Batik
wall hanging, silk, in
oranges, browns, and
off-white. 29″ x 43″.
Collection of the author.

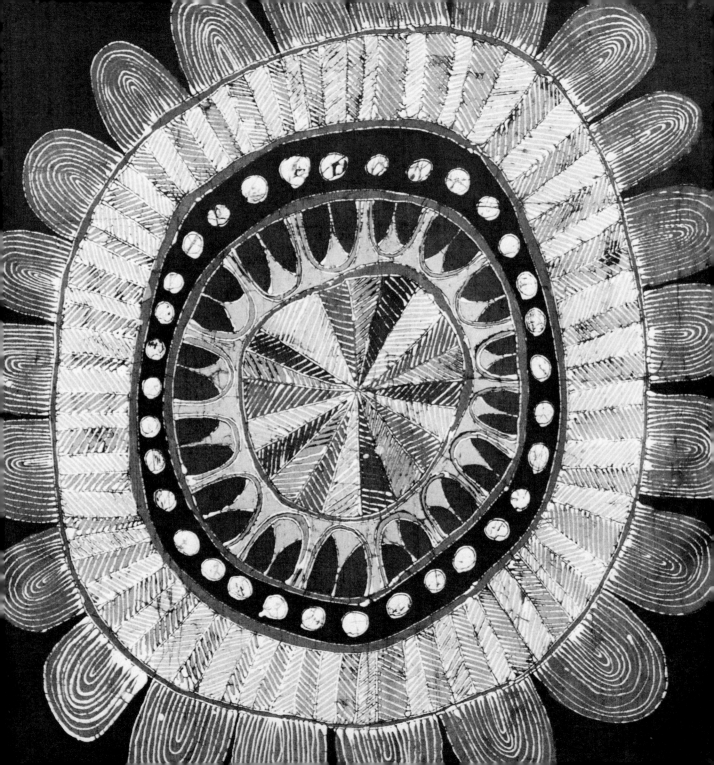

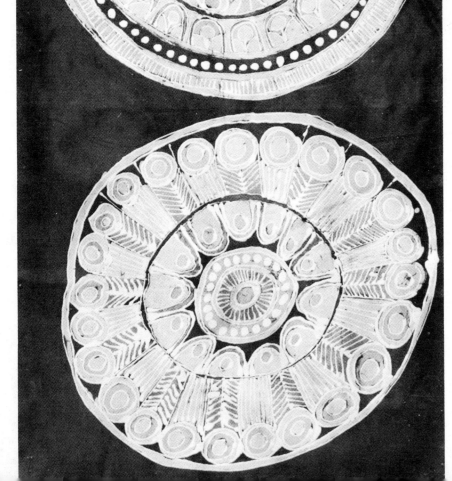

FACING PAGE—Four
circular batik panels.
Example at bottom right
from the collection of
Dr. Norman Leslie,
Seattle.

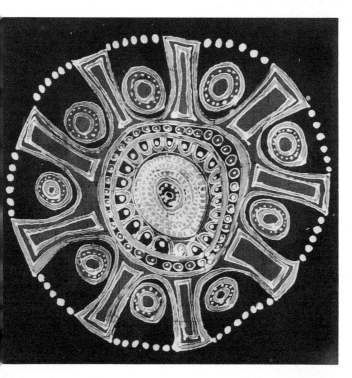
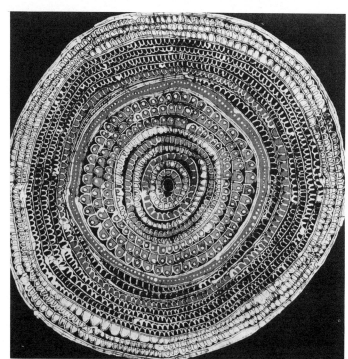
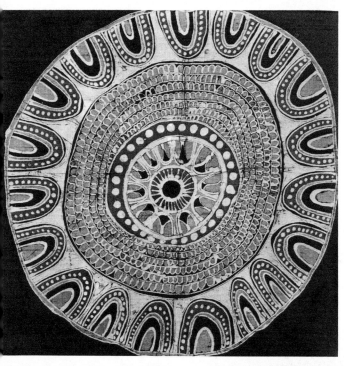
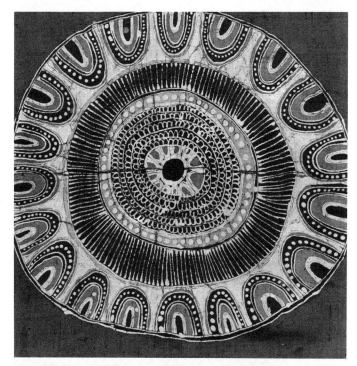

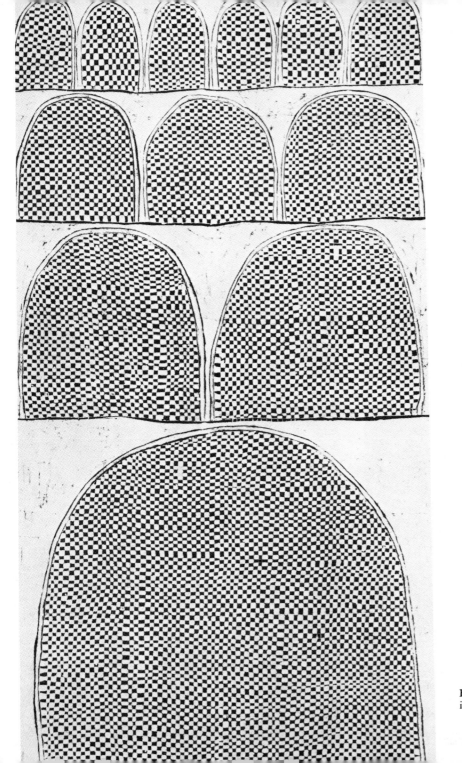

Batik wall hanging, silk shantung, in black and white. 45" x 108".

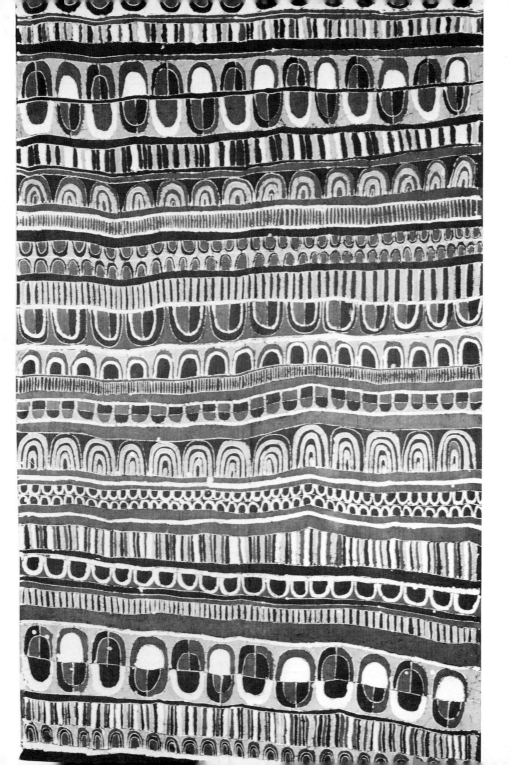

Batik wall hanging, silk, in warm and cool greens. Approximately 40″ x 76″. Collection of G. Finkbiner, Seattle.

131

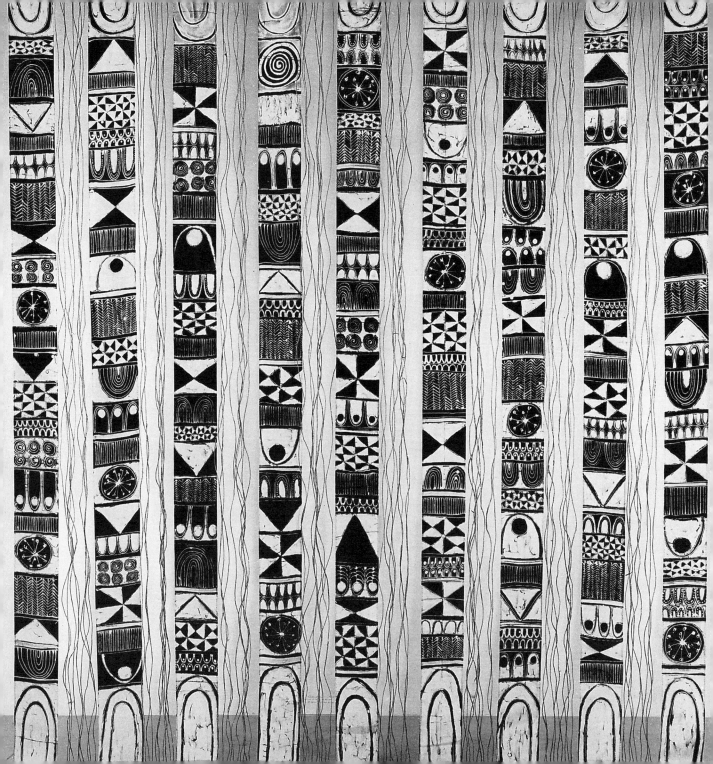

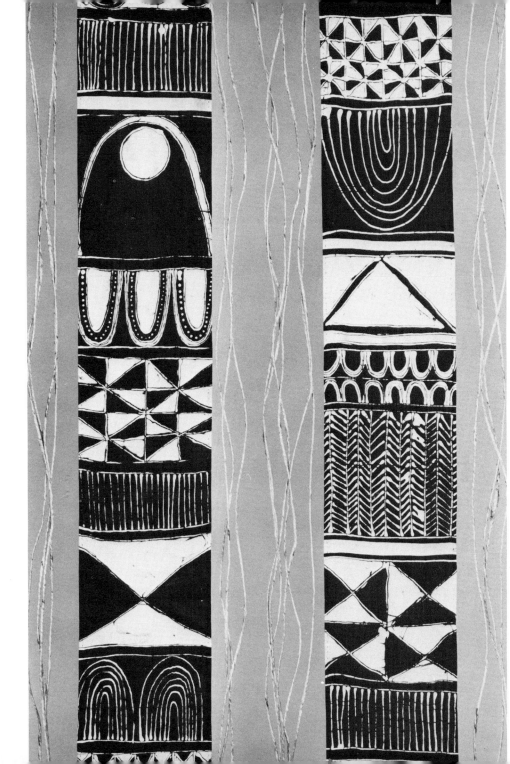

FACING PAGE—Space divider. Silk bands alternate with rows of sisal twine, in indigo and off-white. Approximately 6' x 7'.

Right: Detail of the same piece. Each band is 4½″ wide.

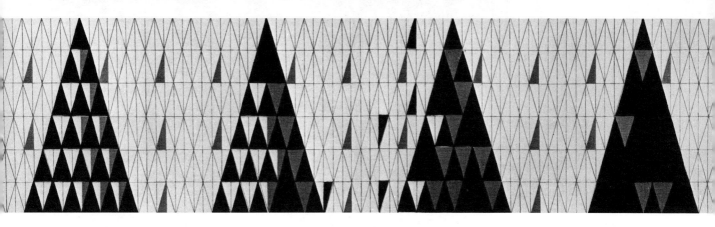

SELECTED BIBLIOGRAPHY

Books on Pattern

Cristie, Archibald H. *Traditional Methods of Pattern Designing*. Oxford: Clarendon Press, 1929.

Day, Lewis F. *Pattern Design*, 2nd ed., rev. by Amor Fenn. London: B. T. Batsford, 1933.

Edwards, Edward B. *Pattern and Design with Dynamic Symmetry*. New York: Dover Publications, 1967.

Fenn, Amor. *Abstract Design*. New York: Charles Scribner's Sons, 1930.

Gourdie, Tom. *Pattern Making for Schools*. London: The Studio Ltd., 1959.

Justema, William. *The Pleasures of Pattern*. New York: Reinhold, 1968.

Kepes, Gyorgy. *Module, Proportion, Symmetry, Rhythm*. Vision & Value Series. New York: George Braziller, 1966.

Seaby, Allen W. *Pattern Without Pain*. London: B. T. Batsford, 1948.

Books on Design

Anderson, Donald M. *Elements of Design*. New York: Holt, Rinehart, and Winston, 1961.

Arnheim, Rudolf. *Art and Visual Perception*. Berkeley: University of California Press, 1954.

Bates, Kenneth F. *Basic Design*. Cleveland: World Publishing, 1960.

De Sausmarez, Maurice. *Basic Design: The Dynamics of Visual Form*. New York: Reinhold, 1964.

Itten, Johannes. *The Art of Color*. New York: Reinhold, 1961.

Kepes, Gyorgy. *Language of Vision*. Chicago: Paul Theobald, 1959.

Scott, Robert G. *Design Fundamentals*. New York: McGraw-Hill, 1951.

Books on Ornament

Alexander, Mary Jean. *Decorative Design and Ornament*. New York: Tudor Publishing, 1965.

Ballinger, Louise B., and Vroman, Thomas F. *Design Sources and Resources*. New York: Reinhold, 1965.

Bossert, Helmuth T. *Folk Art of Primitive Peoples*. New York: Frederick A. Praeger, 1955.

Enciso, Jorge. *Design Motifs of Ancient Mexico*. New York: Dover Publications, 1953.

Encyclopedia of World Art. 15 vols. New York: McGraw Hill, 1959-68.

Escher, M. C. *The Graphic Work of M. C. Escher*, 2nd rev. ed. New York: Meredith Press, 1967.

Gillon, Edmund Vincent, Jr. *Early New England Gravestone Rubbings*. New York: Dover Publications, 1966.

Hornung, Clarence P. *Handbook of Designs and Devices*. New York: Dover Publications, 1946.

Horst, H. P. *Patterns from Nature*. Locust Valley, N.Y.: J. J. Augustin, 1946.

Meyer, Franz Sales. *Handbook of Ornament*. New York: Dover Publications, 1957.

Miles, Walter. *Designs for Craftsmen*. Garden City, N.Y.: Doubleday, 1962.

Piggott, Sir Francis. *Decorative Art of Japan*. London: B. T. Batsford, 1910.

Racinet, Albert. *Polychromatic Ornament*. London: Henry Sotheran, 1877.

Speltz, Alexander. *The Styles of Ornament*. New York: Dover Publications, 1959.

Trowell, Margaret. *African Design*. New York: Frederick A. Praeger, 1960.

Wedd, J., and Dunkin, A. *Pattern and Texture*. New York: Viking Press, 1956.

Books on Technique

Ball, Carlton F., and Lovoos, Janice. *Making Pottery Without a Wheel*. New York: Reinhold, 1965.

Enthoven, Jacqueline. *The Stitches of Creative Embroidery*. New York: Reinhold, 1964.

Harvey, Virginia I. *Macramé: The Art of Creative Knotting*. New York: Reinhold, 1967.

Johnson, Pauline. *Creating with Paper*. Seattle: University of Washington Press, 1958.

————. *Creative Bookbinding*. New York: Dover Publications, 1990. (See section dealing with decorative papers.)

Johnston, Meda Parker, and Kaufman, Glen. *Design on Fabrics*. New York: Reinhold, 1967.

Krevitsky, Nik. *Batik: Art and Craft*. New York: Reinhold, 1964.

————. *Stitchery: Art and Craft*. New York: Reinhold, 1966.

Lauterberg, Lotte. *Fabric Printing*. New York: Reinhold, 1963.

Moseley, Spencer A.; Johnson, Pauline, and Koenig, Hazel. *Crafts Design*. Belmont, Calif.: Wadsworth Publishing, 1962.

Petterson, Henry. *Creating Form in Clay*. New York: Reinhold, 1968.

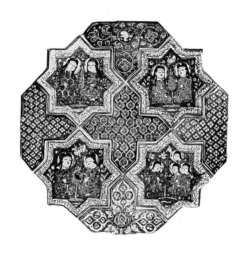